JAPAN AND THE CITY OF LONDON

Japan and the City of London

SIR PAUL NEWALL

ATHLONE
London & Atlantic Highlands, N.J.

First published 1996 by
THE ATHLONE PRESS LTD
1 Park Drive, London NW11 7SG
and 165 First Avenue,
Atlantic Highlands, NJ 07716

© Sir Paul Newall 1996

British Library Cataloguing in Publication Data
*A catalogue record for this book is available
from the British Library*

ISBN 0 485 11501 8

Library of Congress Cataloging-in-Publication Data
Newall, Paul, Sir, 1934–
 Japan and the City of London / by Sir Paul Newall
 p. cm.
 Includes bibliographical references and index.
 ISBN 0-485-11501-8 (hard cover)
 1. Japan--Foreign economic relations--Great Britain--History.
2. Great Britain--Foreign economic relations--Japan--History.
I. Title.
HF1602.15.G7N49 1996
337.520421'2--dc20 96-3350
 CIP

All rights reserved. No part of this publication may be reproduced, stored in a retrieval system, or transmitted in any form or by any means, electronic, mechanical, photocopying or otherwise, without prior permission in writing from the publisher.

Typeset by
Bibloset

Printed and bound in Great Britain by
the University Press, Cambridge

TO MY WIFE, PENNY

Contents

List of Illustrations	xi
Preface by His Excellency the Ambassador of Japan	xiii
Foreword by The Governor of The Bank of England	xv
Acknowledgements	xvii
The Writing of this Book	xxi

1 THE SLEEPER AWAKES AND BECOMES A FIRM
 FRIEND 1
 The Sleeper Awakes 1
 The Japan Customs Loan of 1870, and Early
 Capital Formation 4
 Early Japanese Activity In London 1874-1910 6
 The Japan Society – And The City's
 Involvement 1891-1911 10
 Years Of Alliance 1902-1923 12

2 WEAKENED LINKS IN THE 1920S AND 1930S,
 BUT BACK TO BUSINESS AFTER 1945 17
 Weakened Links 17
 The Post-War Reconciliation 20
 London's Return – The Rise Of The Euro-
 dollar Markets 24
 Investment And Joint Ventures –
 Old Friendships And New 26

3	GLOBALISATION FROM 1960	31
	Global Banking	31
	The Japanese Brokers Focus On London	35
	The Japanese Expand Into The Euromarkets And The Rise Of The Euroyen	39
	London's Competitive Markets In The Mid-1980s	41
	Difficulties With Banking Licences In London In The 1980s	44
4	AFTER BIG BANG: THE LATE 1980S AND A WAVE OF JAPANESE INVESTMENT	49
	After Big Bang	49
	The Impact Of Japanese Direct Investment	51
	Investment By Japanese Life Insurance Companies	61
	Japanese Property Investment In London From 1985	62
5	THE EARLY 1990S – REGROUPING AND RETRENCHMENT	71
	Regrouping and Retrenchment	71
	Japanese Perceptions Of London In Europe – 1991	74
	Polarisation Towards London 1992-4	77
	Security Aspects 1992-4	82
	Lessons Of 1995 – And The European Context	87
6	SPREAD OF INVOLVEMENT – THE GOOD CITIZENS	93
	Japanese Participation In The City's Institutions	93
	Supporting Services – Insurance, Accountancy And Shipping	103
	The Social Context – Charity, Foundations And Education	115
	'Two Strong Men'	117

TEN BRIEF HISTORIES: SOME LEADING JAPANESE FIRMS IN THE CITY	121
Dai-Ichi Kangyo Bank	122
Daiwa Securities	124
Fuji Bank	128
Industrial Bank of Japan	133
Mitsui & Co	136
The House of Nomura	140
The Sakura Bank	146
The Sumitomo Bank	153
The Bank of Tokyo	155
The Bank of Yokohama	160
Notes and References	163
Bibliography	169
Index	171

List of Illustrations

1 Address presented to Admiral H.I.H. Prince Yorihito, Guildhall, 1st November 1918, signed by James Bell, Town Clerk, Corporation of London. *Guildhall Library. Reproduced by kind permission of the Corporation of London, Records Office. (Ent.s.b.1918-21)*

2 Dinner at the Holborn Restaurant, December 1934, to celebrate the 50th Anniversary of the opening of the Yokohama Specie Bank's London office, Chairman Mr H. Kano. *Reproduced by kind permission of The Bank of Tokyo.*

3 'Hats off to the City', c1937, Prince Chichibu-no-Miya (centre), visiting the Yokohama Specie Bank's London office at 7, Bishopsgate (now The Bank of Tokyo). *Reproduced by kind permission of The Bank of Tokyo.*

4 'Out of Hiroshima – A Symbol of Hope and Reconciliation, 1950'. The Mansion House, London. The Mayor of Hiroshima presents to the Lord Mayor of London a cross carved from the wood of a 400 year-old camphor tree, planted at the time of the founding of the City of Hiroshima. The outside of the tree was destroyed by the bomb, but the heart of it was still sound. *Guildhall Library. Reproduced by kind permission of the Corporation of London, Records Office. (P.D.58.2)*

5 H.M. The Emperor of Japan speaking in Guildhall, October 1971, at the State Banquet given in his honour by the Corporation of London. *Guildhall Library. Reproduced by kind permission of the Corporation of London, Records Office. (Print C.194)*

6 Dinner at The Mansion House, 26th February 1981, to celebrate the centenary of The Bank of Tokyo. *Reproduced by kind permission of The Bank of Tokyo.*

7 Official opening of Finsbury Circus House, March 1992, by The Right Honourable The Lord Mayor, Sir Brian Jenkins, G.B.E. *Reproduced by kind permission of The Bank of Tokyo.*

8 The author with Prime Minister Morihiro Hosokawa, Tokyo, March 1994.

Preface by H.E. The Ambassador of Japan

The City of London has a long and fascinating history and, from very informal beginnings, it gradually evolved into a giant among international financial centres in the latter part of the 19th and early part of the 20th centuries, and its prestige remains undiminished today.

After the emergence of the Euromarket in the 1960s, the City has become truly an international community with the market players from many countries. Every possible type of financial transaction is conducted, and the real entrepreneurial spirit of these market players has had limitless influence on markets all around the world. The sense of innovation and creativity, coupled with freedom, responsibility, and an intentional policy strategy to ensure a truly international market, are the true hallmarks of the life of the City and they should never be overlooked or underestimated.

As the author outlines in the book, the Japanese involvement in the City can be divided into two periods. The first was between 1870-1914, when the Japanese government emerged as a borrower in the City, and it was a time when Japan launched a rapid expansion of

industrialization.

The second came after the 1960s, following the Japanese economic recovery from the damage of the Second World War, when Japanese financial firms emerged in the City as international market players.

The approach of the author to the relationship between the City and Japanese firms, is consistently positive. He analyses the contribution made by Japanese firms to the life of the City and it is a great pleasure for me to see Japanese firms performing as good corporate citizens of the City.

I should also like to emphasise the contribution made by the City of London to the financial markets in Japan. These markets have always greatly benefited from the stimulus of the innovation and creativity of the City which has been very important for Japan.

This book provides great insight into the Japanese involvement in the City and it will certainly help to deepen the mutual understanding between the UK and Japan.

Hiroaki Fujii
Ambassador of Japan
London

Foreword
by the
Governor of The Bank of England

The openness of the City of London is a feature of our financial system in which the UK can feel considerable pride. Financial institutions from all parts of the world have established substantial operations here, allowing them to provide a full range of services to their global customers while, at the same time, benefiting the UK by contributing to the depth and dynamism of our financial markets. Institutions from Japan have been as active in this process as any. The major Japanese financial players have, for several decades, been prominent and highly respected members of the UK financial community.

Nowhere is the close relationship between the UK and Japan more evident than in these financial links between our two countries. The financial world is never static; the activities of many financial institutions and the markets within which they operate have changed markedly in the past few years. There have also been changes in geographic focus; European integration is posing new challenges and opportunities for financial institutions in the UK, as the emergence of new markets in South East Asia is doing for those in Japan. Far from being weakened by these

developments, financial relations between our countries are as healthy as they have ever been and the Japanese presence in London as strong and welcome as at any time.

There have, as this volume records, been occasional difficulties to be overcome. It is inevitable that the relationship between countries with different cultures and traditions will encounter obstacles from time to time. The fact that these arise should not concern us over much; what is infinitely more important is that the parties concerned share a sense of determination and common purpose in overcoming them. Sir Paul Newall's book chronicles, with admirable thoroughness and clarity, the development of a valuable and mutually beneficial relationship. It provides a unique perspective of the evolution of financial relations between our two countries and, in adding to our understanding of the past, will make an important contribution to strengthening still further the ties between us in the years to come.

Eddie George
The Governor
Bank of England

Acknowledgements

My first acknowledgements are to Mr Brian Southam of The Athlone Press who encouraged me to write this book, and to Professor Theo Barker of the Department of Economic History, London School of Economics, whose comments, guidance, and stimulating suggestions have been invaluable. Early encouragement from His Excellency the Ambassador of Japan (H.E. Mr Hiroaki Fujii) helped to launch my work on this book, and I am deeply grateful for his support, for his agreeing to write the Preface, and for the help of the Financial Minister, Mr. Y. Matsuo. My sincere thanks are also due to the Governor of the Bank of England, Mr Eddie George, for his assistance and that of his advisers, in particular Sir Peter Petrie, C.M.G., Mr John Kirby and Mr Paul Wright.

The Foreign and Commonwealth Office have been supportive, and my thanks go in particular to Sir John Boyd, K.C.M.G., lately H.M. Ambassador in Tokyo and to Mr. David Wright, C.M.G., L.V.O., his recent successor. Among past Ambassadors to Japan, the late Sir Fred Warner's writings have been of particular value, as have those of Sir Hugh Cortazzi, G.C.M.G. whose encouragement and constructively critical comments have been especially helpful.

The Corporation of London has been generous with its

help. I have to thank, in particular, Mr Michael Cassidy (Chairman of the Policy and Resources Committee), Mr Adrian Barnes, C.V.O. (The Remembrancer), Mr James Sewell (The City Archivist) who, with his staff, has facilitated my research, and Mr E.T. Hartill (City Surveyor).

I have received essential help in my task from a host of individuals and I am grateful for this opportunity to record their names, together with my appreciation of their support. In alphabetical order, they are: Dr David Atterton, C.B.E., of Guinness Mahon Holdings, Mr David Brewer, of Sedgwicks, Mr George Bull, O.B.E., of the Anglo-Japanese Economic Institute, Mr Bill Clark, C.B.E., Mr John Clay, of Clay Finlay Inc., Mr Robert Craigie, Mr C.J. Farrow of LIBA, Mr Bruce Farthing of Intercargo (who advised on shipping), Professor Raoul Franklin, C.B.E., Vice-Chancellor of City University, Mr David Glascock and Mr Keith Knowles, of Weatherall, Green & Smith (who were most helpful on property matters), Mr Michael Hart, of Foreign and Colonial Management Ltd, Mr David Hodson of LIFFE, Sir Nicholas Hunt, G.C.B., L.V.O., of the Chamber of Shipping, Mr T.L.G. Landon (who was very helpful on insurance matters), Mr John Manser, C.B.E. and Mr Patrick Gifford, of Robert Fleming & Co., Mr John Morrell of John Morrell Associates, Mr Carel Mosselmans, Professor Ian Nish, Mr Andrew Pace of the Willis Corroon Group (whose guidance on insurance matters is very much appreciated), Sir Peter Parker, K.B.E., L.V.O., Mr Robert Pringle of Central Banking Publications, Mr John Robins, of Guardian Royal Exchange plc, Lord Roll of Ipsden, K.C.M.G.,C.B., Mr Michael Turner of Touche Ross & Co (who kindly advised on accountancy), Mr David Sizer and Mr John Slade, of Richard Ellis & Co (whose advice on property matters was so very useful), Professor Andrew Smithers, The Viscount

Acknowledgements

Trenchard, of Kleinwort Benson & Co, and Mr Ben Wrey, of Henderson Administration.

The writing of this book would have been impossible without the co-operation and comments of the Japanese business houses in London. They have responded generously to my questions, questionnaires and requests for material. At Dai-Ichi Kangyo Bank, Mr T. Murai deserves my thanks, and at Daiwa (Europe), Mr Nicholas Clegg and Mrs Miyoko Stevenson were most helpful. I am grateful also to Mr Takeuchi at the Fuji Bank, and I wish to record my thanks to Mr Fukumuro of Mitsui & Co. for his valuable time and help. Miss Haruko Fukuda of Nikko (Europe) has given me an invaluable insight into the history of the Japanese brokerage community in London, and I express my thanks for her time and her kind permission to reproduce excerpts from her speeches. I have also received generous help advice and encouragement from Dr Andreas Prindl of Nomura Bank International, who has given me valuable material.

I record my thanks to Mr S. Mori of the Sakura Bank for his willing co-operation. At the Bank of Tokyo, Mr T. Kurachi has been especially supportive and I am also grateful to his secretary, Miss Suzanne Lofthouse, for her work in researching some of the photographs used.

At Lehman Brothers, my excellent and patient secretary, Miss Tessa Munro did sterling work with the translation of my handwritten text into modern form; her help has been vital in the preparation of this work.

I owe a debt of gratitude to my father-in-law, Sir Julian Ridsdale, C.B.E., who, over the past 26 years, has encouraged me to widen my circle of Japanese friendships and acquaintances, and has made countless introductions which have borne fruit in the form of help and co-operation from so many Japanese.

Lastly, nothing could have happened without my wife

Penny, to whom this book is dedicated. She has been at my side throughout, not just by way of encouragement, but with countless hours of work, typing, correcting, advising and preparing the index. My greatest thanks belong to her.

<div style="text-align: right;">Paul Newall</div>

The Writing of This Book

The story of Japanese involvement in the City of London starts in the 1870s. Factors which led to London becoming Japan's main source of overseas financial services until 1914 were linked with the requirements of Japanese foreign policy as well as trade. From the mid-1960s, after the advent of the Euromarkets, London was again to become the main focus of Japanese financial expansion. Overall, social, diplomatic and military history played varying parts in the early formation of the economic and financial relationships which developed so strongly. Mutual respect and British hospitality were also important, and both were reinforced by long-term perceptions of economic and political self-interest on both sides. This book attempts to draw all these strands together, and to demonstrate the many factors which made such a strong relationship sustainable, and renewable.

The many Japanese firms which brought their business to the City of London have contributed strongly, and in different ways, to the development of London into what is now the leading centre for international financial business in the world. As these Japanese businesses have expanded their international operations, they have become significant customers for London-based services including

insurance and reinsurance, banking and leasing services, transactions in international capital markets, international direct and portfolio investment, legal services, accountancy, and consulting services. All these help to form the critical mass of supportive professional services and expertise which now provides the best service Euro-wide, and in many areas, world-wide. More visibly, Japanese banks and securities houses, property companies and even insurance companies have established themselves physically, and have become major investors and employers, as well as being active participants and users of the City's markets. Japanese nationals now play their part on the governing bodies of several institutions and enter into the life of the City community, of which they are now an integral and very important part.

In 1990, the then Chairman of the Japan Committee of the British Invisible Exports Council (now British Invisibles) wrote 'Japanese firms have been exemplary employers . . . the Committee hope that Japanese financial firms may, in due course, obtain recognition for their contribution to the invisible exports of the UK, in the same way as Japanese industrial firms have contributed to our visible account'. This book also attempts to summarise that contribution, and to give that recognition.

As Lord Mayor of London for the twelve months from mid-November 1993, I had from my mayoral home base at the Mansion House first-hand experience of the concerns of the City-based Japanese financial community. These concerns were overwhelmingly related to security, after the terrorist bomb in the City in 1992, followed by another which devastated Bishopsgate in April 1993. The terrorists made it clear that they were targeting the international financial community (excepting American firms), whose confidence was crucial to London's success as an international centre.

One of my early priorities was to invite as many of the leaders of the Japanese City-based firms as possible to the Mansion House to hear their views, and to reassure them of the Corporation of London's broad range of measures to deter future attacks. I deliberately, made Japan the focus of my first major overseas visit, so as to be able to pay my respects and to speak to the main corporate and government leaders in Tokyo.

My aim was to bring the Japanese community even closer to the City by demonstrating our real concern for their welfare, and that of their families and employees. I was, after all, their chief host in the City of London. I became increasingly impressed by the spirit of their commitment to the City, by the huge part they played in the City's prosperity, and by their willingness to share fully in the City community as good citizens. It has therefore been a great pleasure to write this book as a tribute to them as honoured members of our most international of cities.

<div style="text-align:right">Paul Newall</div>

CHAPTER 1

The Sleeper Awakes and becomes a firm friend

The Sleeper Awakes • The Japan Customs Loan Of 1870, And Early Capital Formation • Early Japanese Activity In London 1874-1910 • The Japan Society – And The City's Involvement 1891-1911 • Years Of Alliance 1902-1923

THE SLEEPER AWAKES

> *In the latter half of the 19th Century . . . Japan awoke from its long isolationist slumber and put all its efforts into reforming its political, economic, and social structure so that it could speedily stand alongside the Great Powers of the time. Britain was our teacher then and, I think, Britain still is.*
> (Speech by H.E. Hiroshi Kitamura, Ambassador of Japan, to the Institute of Directors, December 1993)

Commodore Perry's landing in Edo Bay had, in 1853, opened American links, and paved the way for the first Treaty with the United States. It was the British, however, who were to become foremost in helping

Japan make the transition from feudalism to a modern industrialised nation.

The British already enjoyed a flourishing trade with China, especially in importing tea from there, and were well placed to take advantage of the trade treaties signed in 1858 which opened up some Japanese ports. Indeed, British trade with Japan was almost immediately to exceed that of any other nation, and the British soon established their own trading posts there. In 1859 William Keswick of Jardine Matheson, already well established in China, was the first British trader to settle in Yokohama, one of the first two treaty ports. In the same year the Aberdonian Thomas Blake Glover arrived in Nagasaki, which had previously maintained a very restricted trade with the Dutch and Chinese and was, therefore, the obvious choice as the other treaty port. In 1861 he acted there for Jardine Matheson besides pioneering dry dock facilities and introducing British coal mining techniques into Kyushu. John Swire & Sons of Liverpool[1] compensated for trade lost across the Atlantic during the American Civil War by sending textiles to China and Japan and established posts in Yokohama and Kobe, acting as insurance agents for the Royal Exchange Company.[2] Soon, Japanese students such as Prince Ito and his friends, encouraged and helped by William Keswick in Yokohama and Hugh Matheson in London came to study in Britain and were introduced to the City of London.

The Meiji Government encouraged Britons to come to Japan and help Japan's development with their expertise. Sir Harry Parkes, the British Minister to Japan at the time, did much, in advising them, to encourage the growth of a modern industrial society.[3] Partly as a result, by far the largest number of foreign employees in Japan in the latter part of the 19th century were British. Parkes encouraged the appointment of Richard Brunton as Chief Engineer

of the Japanese Government's Lighthouse Department; Brunton's interests were extensive and he was later to pioneer the first telegraph lines in Japan, which in turn led to the establishment of telegraphic communication with London. Parkes also did much to advocate improved telecommunications and better roads, as well as to encourage the Japanese Government to develop a railway system.

Japan was now becoming a diligent pupil of western civilisation and practice. No country has so rapidly shaken off the shackles of old tradition or so eagerly welcomed western thought that took its place. Patriotism was the spur, and the will to transform Japan into a world power in the East. Education was the key, and foreign teachers in Japan together with study by Japanese abroad were the vital ingredients of the new order. A British banker in Japan, Allan Shand of the Chartered Mercantile Bank's Yokohama office, played a valuable role in the development of Japanese financial skills. He did so by guiding and training young Japanese who were later to become leaders in the financial field[4] – such as Taguchi, the founder of *The Tokyo Economist*, the Sasaki brothers, Kobayashi, Vemura, and a future Prime Minister, Takahashi. Shand published the first textbook, in Japanese, on the skills of book-keeping; he advised the Banking Bureau, established in 1874, and in his treatise *On Banking* explained the workings of the British banking system to an extensive readership in Japan. Through his endeavours, British economic and financial theory and practice became strongly established, and this was to have important consequences later. Attempts to establish a Stock Exchange on British lines did not succeed; but a group of Japanese businessmen themselves established a workable Exchange in 1878. By 1880 half of Japan's foreign trade was being handled by British trading houses.

Japan, in her drive to become a modern power, had

turned to Britain as the main source of expert advice, and by the end of the nineteenth century, the British community in Japan accounted for about one-half of the entire foreign presence.

THE JAPAN CUSTOMS LOAN OF 1870, AND EARLY CAPITAL FORMATION IN JAPAN

No system existed for the private formation of capital, and the early industrial enterprises in Japan in the 1870s were financed by government via bond issues. The Japanese government, constrained by capital shortage, opened the way for private enterprise. The first joint stock companies were the railroads, followed by mining and cotton spinning. The banks lent the money, using the stocks as collateral.

In 1869, the new Meiji ministers, after some argument amongst themselves, determined to seek a foreign loan to finance Japan's first railway to connect Tokyo with the port of Yokohama. In that year, an Englishman, with the emotive name of Horatio Nelson Lay, persuaded the Japanese Government to let him put together, and to be the commissioner for, a total loan of £1 million. Interest was to be secured on customs revenue.

J. Henry Schroder & Co, the London merchant bank, was the only London house prepared to participate, in conjunction with Emile Erlanger in Paris. Accordingly, in April 1870, Schroders brought out the issue – a 10 year £1 million Imperial Government of Japan Customs Loan, with a coupon of 9 per cent, receiving 1 per cent commission for its services. Although the coupon was at the high end of the range for established sovereign borrowers, it was deemed to be very reasonable for the government of a country so new to international capital markets. Unfortunately, it became clear that the Japanese

Government had initially agreed to pay Lay 12 per cent for his part in finding willing banks, and, in the wake of public outcry, Lay's 'turn' of 3 per cent was cancelled by decree. The Japanese were delighted by Schroder's part in such a successful introduction and by the subsequent performance of the Bond which soon sold at a premium. This successful launch played a useful part in bringing to the attention of the City of London, and to investors generally, the positive developments in the Japanese commercial and transport infrastructure and the Government's new direction. Upon redemption of the Bond in 1882, the Japanese Government's gratitude was marked by the presentation of a fine vase to Schroder's office manager, Mr Foreman, by the then Minister of Finance Prince Matsukata Masayoshi 'as a mark of our esteem for the trouble you have taken'.[5]

A second loan was raised in London for £2,400,000 in 1873 (with a coupon of 7 per cent and well oversubscribed) through the good offices of the Oriental Banking Corporation which had become the main foreign banker in Japan and agent for the Japanese Government. Other, smaller, commercial loans were also made by the Hong Kong and Shanghai Banking Corporation, and others, to Japanese businesses, but the Government raised no further foreign loan for another 24 years.[6]

By the 1880s, utilities and manufacturing joined the ranks of private enterprise companies and although stock ownership remained limited to a wealthy few, stock exchange activity, encouraged by the Commercial Code of 1899, grew rapidly. Victory in the Russo-Japanese War was a strong stimulus, and it is recorded that during the stock exchange boom in 1906, trading volume rose above 10 million shares. Stock exchange firms such as Nomura Shoten were by now well-established, and expanding their operations.

EARLY JAPANESE ACTIVITY IN LONDON 1874-1910

Japan's overseas trade rose very rapidly with the advent of the Meiji Government and expanded nearly twenty-fold in the 22 years until 1890. Earlier exports were mainly silk and tea, but 1874 was a landmark, when Okura & Co opened the first overseas office of a Japanese commercial house in London; and in 1879 the trading house of Mitsui established a London office. As a result rice was added to British imports from Japan.

The Japanese Government was anxious to establish a degree of financial independence for its trade; it lent money at subsidised rates to its exporters so as to lessen their reliance on foreign houses. In return, the foreign currency earnings resulting from this overseas trade were deposited abroad and these monies were almost invariably remitted to London to be held for Japanese Government account by the Oriental Banking Corporation; (after the latter went into receivership in 1884, this role was taken over by the London Joint Stock Bank). Responsibility for payments to service Japan's foreign loans was assumed by the Yokohama Specie Bank, which opened its office in the City of London in 1884, as the Government of Japan's agent. This was the first Japanese banking presence in London.

The revolution in world communications in the later nineteenth century strengthened the City of London's position as the world's financial centre. It also encouraged the internationalisation of the money market and accelerated the role of sterling for international payments, and the use of the foreign bill on London as the medium for the growing volume of international trade financed by the City's discount and accepting houses. The role of sterling continued to grow, and by 1914 about half of world trade was settled in the pound sterling. London had indeed

become the principal banker to the world. In 1894 a Treaty of Commerce and Navigation was signed by Britain and Japan thus replacing the 'Unequal Treaty' of 1858. A strong and cordial relationship had been established.

The cost of financing the Sino-Japanese War in the 1890s again led the Japanese to London for funds after a long period of self-financing. The development of Japanese Government borrowing using London as the main source, has been well documented in a recent book by Professor Suzuki.[8] In it, he underlines how important it was that Japan, a little-known and seemingly high-risk country should establish its credit rating in the City of London. The fact that Japan was able to borrow on relatively favourable terms and to establish its early creditworthiness owes much to the sophistication of London's capital markets at the time – and also to the intelligent perception of Japan's own financial leaders. London's significance as an international banking centre can be gauged by the decision of the Japanese Government, following the Sino-Japanese War, that the large Chinese indemnity due to Japan from 1895 to 1898 be paid mainly through a special account opened by the Bank of England.

The first of the new loans to be raised in London was the Japan Government Loan of 1897, the consortium consisting of Hong Kong and Shanghai Bank, the Yokohama Specie Bank and the Chartered Bank. This was followed, in 1899 by a further loan for £10 million, the consortium being led by Parr's Bank.[9] The latter was a clearing bank, whose Lombard Street branch manager was Allan Shand, formerly the Yokohama manager of the Chartered Bank. Shand had been an early adviser to the Japanese Government on the establishment of English-style banking, and had returned to London in 1878 to work for the Alliance Bank which then merged with Parr's. He was also a friend and former colleague of Korekiyo Takahashi,

the Deputy Governor of the Yokohama Specie Bank, who later was to oversee the Japanese Government's London loan negotiations. This particular issue was a failure, over 90 per cent of it remaining with the Japanese Government and the underwriters. It was said at the time that Japan's credit rating in the City was still poor and that the issue lacked the support of the London merchant banks. Such support was of critical importance, as Professor Suzuki's book points out, since Rothschilds and Barings were able to gain access for later issues to continental European and American markets. Suzuki also demonstrated that the London stockbrokers, Panmure Gordon, in acting as broker to these issues, provided valuable service organising the underwriting syndicates and often coping with difficult after-markets.

Greater success was achieved with a £5.1 million issue in 1902, denominated in yen. This had the support of the Foreign Office who (unsuccessfully) urged Rothschilds to become the lead issuer in the following terms 'it is a matter of political importance that Japan should be able to raise in this country, rather than elsewhere, the money which she requires'. Barings, under the chairmanship of Lord Revelstoke ended up as the lead issuer, jointly with the Hong Kong and Shanghai Bank and the Yokohama Specie Bank, and the issue was adjudged a great success.[10]

The earliest evidence of British institutional investment in Japanese Government paper is contained in the Annual Report of the Foreign and Colonial Trust Company of 1881 showing a holding of 'Japan 7 per cent 1873'. The same institution had, by 1903, £55,000 invested in four Japanese loans amounting to 2 per cent of its total portfolio.[11]

By 1902, the banking affinity between London and Tokyo, in the cordial atmosphere of the Anglo-Japanese Naval Alliance, was underlined by the visit of Finance

Minister Prince Matsukata Masayoshi. Nori Tamaki's account of *Japan's Adoption of the Gold Standard and the London Money Market 1881-1903*[12] describes Matsukata as Japan's leading financial expert in the early period of Meiji. He had dominated the financial scene in Japan for the previous two decades, was already highly respected, and was received in London as a visitor of the first rank. Adulatory comments in the British press, a visit to Buckingham Palace to be received by King Edward VII, and banquets in his honour by the Foreign Secretary and others all confirmed the significance of his visit. The importance of the London Money Market, and Matsukata's conviction that Japan should go on the Gold Standard had led him, as Premier as well as Finance Minister, to ensure that the Monetary Act adopting the Gold Standard passed The Diet successfully in 1897. In the King's Birthday Honours of 1903, Matsukata was made an honorary G.C.M.G. for his distinguished services to finance.

In late 1903, war between Japan and Russia seemed imminent. The then Lord Mayor of London, Sir Marcus Samuel who, as we shall see, was favourably disposed to the Japan Society in London, was unsuccessful in trying to persuade the British Government to guarantee a £10 million loan,[13] and the Japanese Government again turned to the City's bankers. By February 1904, war had been declared, and, in that same month, Takahashi, now Vice-Governor of the Bank of Japan arrived as finance commissioner in London to negotiate the £10 million borrowing. Early Japanese military and naval successes ensured that pro-Japanese sentiment in London was running high. With Parr's, the Hong Kong and Shanghai and the Yokohama Specie banks again leading, the issue was launched on both sides of the Atlantic in May 1904, being nearly 30 times oversubscribed in London. Japan's credit rating was now firmly established, and further successful

issues followed rapidly - with another £12 million loan being issued in the same year. The pace of borrowing was such that, in 1905, the Bank of Japan opened its London office to supervise the agent banks authorised to make the payments. There followed a £30 million loan in March 1905, and a further £30 million loan in July that year – part offered in Germany, £25 million in 1906, split between Paris, London and Berlin, and £23 million in 1907, equally split between Paris and London. By now, thanks to the international connections of the City's merchant banks, especially Rothschilds, these syndications were truly multinational.

In all, between 1897 and 1910, about £200 million was raised by the Japanese Government through London, very largely through the London Group, as the main consortium became known. A significant effect of all this borrowing was the substantial build-up of balances owned by Japan in London which, in gold specie, could be moved out at any time, thus injecting a potentially unstable element in Britain's gold reserves. This was to become an embarrassment later.

THE JAPAN SOCIETY – AND THE CITY'S INVOLVEMENT 1891-1911

At a meeting of the Japan Section of the International Congress of Orientalists in London in September 1891, a resolution was passed calling for the establishment of a Society 'for the encouragement of Japanese studies and for the purpose of bringing together all those in the United Kingdom and throughout the world, interested in Japanese matters'. This led to the immediate creation of The Japan Society in London later called, more simply, The Japan Society.

A council was formed and, at a general meeting at

the Royal Society of Arts in December 1891, the Society was formally established. Professor William Anderson F.R.C.S., an expert on Japanese art, became the first Chairman of the Council. The first President was the Japanese Minister, Viscount Kawase, and the Minister (later the Ambassador) of Japan has ever since been its President. The Society's first lecture was held on 29th April 1892. Its lecture programme has always been one of the most important elements of its activities, covering a range of Japan-related themes, historical, cultural and topical, delivered by distinguished experts from Britain and Japan. The texts have filled the bulk of the printed *Transactions and Proceedings of the Japan Society*, the first volume of which was produced in 1892. The first annual dinner of the Society was held on 23rd June 1892.

Lord Mayors of London[14] enjoyed early involvement with the Society, and, in July 1894, the then Lord Mayor, Sir George Tyler and the Lady Mayoress entertained the members, together with the Japanese Minister, Viscount Aoki. The Mayoralty and Corporation of London were to be prominent in the hospitality offered to the Society, and to leading Japanese dignitaries. In 1903, Sir Marcus Samuel (later Lord Bearsted), the then Lord Mayor, and Lady Samuel entertained the Japan Society at the Mansion House, where an exhibition of bonsai and Japanese flower arrangements were on display. Two years later, the visiting Prince Arisugawa was entertained at the Mansion House to luncheon where he read a telegram from the Emperor conferring the Order of Commander of the Rising Sun on the Lord Mayor. The City continued to foster good relations between the two countries. In 1906, for instance, the Lord Mayor established a Mansion House Fund to relieve the suffering of those affected by a famine following the failure of the rice and silk crops in north-east Japan. Mayoral hospitality was also evident in the farewell

luncheon in 1906 for the departing Ambassador, Viscount Hayashi, and also in a luncheon given there, in honour of the Japanese Navy, for twenty-eight officers. Subsequently, three hundred Japanese sailors visited St Paul's Cathedral to pay their respects at the tomb of Admiral Lord Nelson. The Guildhall, the City of London's seat of government was, in 1907, the setting for Corporation of London hospitality for H.I.H. Prince Fushimi, followed by a luncheon at the Mansion House, Lord Mayor Sir William Treloar presiding, in the presence of H.R.H. The Prince of Wales. Prince Fushimi, as Representative of The Emperor found the City's Streets decorated in his honour, and, at the luncheon, one hundred boys from the Duke of York's Military School sang the Japanese National Anthem, in Japanese.

In 1910, the Japan Society organised the Japan-British Exhibition at Shepherd's Bush. This was launched at a meeting at the Mansion House, where the Lord Mayor gave hearty support to the great undertaking; one of the features of the exhibition was the participation of one of the City's Livery Companies, the Worshipful Company of Fanmakers, who hoped thereby to revive British interest in fans. Sir Joseph Dimsdale, Bt. (Lord Mayor of London 1901-2) was elected Chairman of the Council of the Japan Society in 1911.

YEARS OF ALLIANCE 1902-1923

The Anglo-Japanese Naval Alliance, signed in February 1902 (renewed in 1905 and 1911), together with the links with the Royal Navy and to British naval construction and armaments companies, was crucial to the development of Japan as a modern, sea-going power and a natural accompaniment of London's financial support. The furnishing by Armstrong's and Vickers of Japan's warships

contributed much to the naval victories over Russia in 1904-5. Japanese Admiralty officials had visited Tyneside and Barrow-in-Furness to buy the latest vessels of war. Earlier, technology transfer had been achieved by Japanese shipbuilding engineers who had come to Britain; Japanese sailors had also come to learn how to operate the guns and ships before they were taken to Japan. These links predated the Anglo-Japanese Alliance and, indeed, harked back to 1862, when a party of Japanese had visited The Royal Arsenal to observe the casting and fitting of Armstrong guns.[15] It was Armstrong's who supplied the first guns and ammunition to Japan in 1865, through Thomas Glover, Jardine Matheson's agent in Nagasaki, on behalf of the Japanese Government. Admiral Togo's great victory over the Russian fleet in 1905 at the Battle of Tsushima even had a Nelsonian echo. The following signal was sent from Togo's flagship, the Mikasa, just before battle was joined 'the fate of the Empire depends upon this battle. Let every man do his utmost;' The battle of Tsushima was, in a way, Japan's Trafalgar.

When, in 1914 Great Britain declared war upon Germany, Japan, in accordance with the Anglo-Japanese Alliance, sent an ultimatum to Germany on August 4th . When no reply was received, Japan declared war on Germany on August 23rd. The Emperor Yoshihito's Imperial Prescript included the words, 'accordingly, our Government and that of His Britannic Majesty . . . agreed to take such measures as may be necessary for the protection of the general interests anticipated in the Agreement of Alliance . . . it is with profound regret that We . . . are thus compelled to declare war'.[16] The German territory of Kiaochau was soon to be attacked by a joint Japanese-British expeditionary force, and after the fall of Tsingtao, Japanese forces went on to occupy the German-controlled islands of the Pacific. Japan rendered

further valuable assistance to the Royal Navy in the Pacific and in the Mediterranean during the 1914-18 war, and even offered to send 'a picked quarter of her two million men to the European theatre of war'. Japan had indeed honoured her obligation to Britain.

Back in London, financial relationships in the year leading up to the Great War could not have been closer. It could be said that, to the Japanese, an effective financial alliance was part of the relationship of trust which nurtured the more formal Alliance between the two countries, which was certainly central to Japan's entire overseas policy and mutually beneficial. I have already referred to London's pre-eminent role in the raising of loans for the Japanese Government, and the use of the Bank of England for depositing Japan's foreign exchange earnings.

It had become increasingly useful to Japan to maintain large balances at The Bank of England in order to meet financial obligations, without having to export specie from Japan. This arrangement worked to the benefit of both parties. In his book *Anglo-Japanese Financial Relations*,[17] the late Sir Fred Warner listed the reasons for the choice of London as the focal point of Japan's overseas finances as follows:-

1. London was the leading centre of world finance with the greatest range and expertise of service.
2. London had the world's largest silver market and was the best place in which to exchange reserves of silver into gold (Japan was in the process of shifting to the Gold Standard).
3. Britain was second only to the United States in importance for Japanese trade – and Japan had large trade deficits with Britain necessitating large cash transfers in London.

In London, apart from the activities of the Yokohama Specie Bank, there was no lasting presence established

during this period by Japanese commercial banks. In spite of the concentration of Japanese official financial operations, the other Japanese banks remained absent. A joint venture, the Anglo-Japanese Bank was formed in 1906, with both British and Japanese directors, to finance trade, but was dissolved in 1914. Some joint commercial ventures, however, were developed, with British companies such as Dunlop, Vickers and Armstrong Whitworth, for manufacturing construction in Japan, for rubber products, steel and armaments.

The weakening of the European powers, including Britain, as a result of the War, led Japan, by now the strongest power in East Asia, to pay rather more attention to her relationship with the United States, which had emerged from the conflict as a much stronger haven.. During the war, Japan's export trade had flourished, and her shipping fleet had increased very substantially. The economic benefit was most marked in the shift to a favourable trade balance, strongly assisted by the growth of manufactured products as a percentage of total exports.

By the end of the war, Japan had become, on balance, a creditor nation, and the yen had become a strong currency. The need for more foreign loans was no longer a major factor in economic and political policy. Indeed, the wheel had turned; allied governments were now able to sell bonds in the Japanese domestic market, including £10 million in 1916, payable from the overseas balances. In that same year, the British Government sold Japanese currency bonds (10 million yen) for the first time, followed in 1918 by an 80 million yen issue. Borrower had become lender indeed, and by the end of 1918, Japan had become, after the United States, the second largest creditor nation in the world.

Because Britain embargoed the export of specie during the war, while the USA did not do so until it entered the

War in 1917, New York's importance increased relative to that of London. While Japan's blocked balances in London accumulated until 1918 with as much as two thirds of her foreign exchange reserves involved, that country understandably encouraged the invoicing of foreign trade in New York whenever possible. As a result, the yen became increasingly US dollar based, and the former prime linkage with the pound sterling was to be ended. The close relationship with the City of London was much eroded by the new currency alignment and indeed by Japan's increasing reluctance to hold reserves abroad at all, in spite of the potential domestic inflationary impact of such a shift. In 1919, therefore, the Japanese Ministry of Finance placed a limit on the amount of specie held in Britain. Japan's currency reserves held in London were to decline steadily from then on.

Recognition of the part which Japan played as Britain's ally in World War One was celebrated when Admiral H.I.H. Prince Yorihito of Higashi-Fushimi visited London in November 1918. He came to the City, to be received by the Lord Mayor at the Guildhall and was presented with an Address at a Reception given by the Corporation of London in Guildhall. The letter, signed by the Town Clerk, was clear evidence of the appreciation of Japan's role in the war with Germany.

It is one of the ironies of history that the popular visit of H.I.H. The Crown Prince Hirohito, later to become Emperor, in May 1921, was followed later that year by the Washington Conference leading to the end of two decades of the Anglo-Japanese Alliance.

CHAPTER 2

Weakened Links In The 1920s And 1930s But Back To Business After 1945

Weakened Links • The Post War Reconciliation • London's Return – The Rise Of The Eurodollar Markets • Investment And Joint Ventures – Old Friendships And New

WEAKENED LINKS

Following the ending of the Anglo-Japanese Alliance, in 1923, there was further deterioration in the relationship. The Alliance had been regarded by the Japanese as the cornerstone of their global diplomacy, and its disappearance was badly received. Indeed, it could be said that this event was a great tragedy in the Anglo-Japanese relationship. The treaty had great symbolic value in Japan, and its abandonment by Britain had a bad effect on attitudes to foreigners generally.

As we have seen, the links with London had already been weakened, and a shift in economic power had already lessened Japan's reliance on London. The yen was already

mainly linked to the US dollar, and New York became the focal point for Japanese exchange-rate policy and for the raising of loans by the Japanese Government. Between 1923 and 1931, more than twice as much money was raised by Japan in New York as in London.[1] In 1924, a £60 million Japan Government Loan was underwritten in London; the syndicate, headed by the Westminster Bank included the Yokohama Specie Bank, the Hong Kong and Shanghai Banking Group, Rothschilds, Schroders, Morgan Grenfell and Baring Brothers, with Panmure Gordon acting as brokers. 60 per cent of this Loan was placed in New York, however, underlining the shift in emphasis from London. Subsequent loans in 1925, 1926 and 1930 were, in the main, placed in New York. It is fair to add that simultaneous loans in London and New York, with 'dual tranche' structures were only made possible because US investors' wariness of foreign bonds was allayed by the knowledge that these Japanese issues carried the quality approval of the City of London.[2]

The close links with the City of London were further weakened by the refusal of the Governor of the Bank of England to support a loan for the City of Tokyo to finance reconstruction after the devastating earthquake in 1923. Sir Fred Warner's book on Anglo-Japanese financial relations described [p. 95] how the Japanese Financial Commissioner, Kengo Mori wrote to the senior partner of Panmure Gordon, Alan Cameron, that whereas the City of Tokyo's motto had traditionally been London 1st, New York, 2nd, 'when you and your friends found the Governor of the Bank of England adamant last autumn in spite of your repeated efforts to promote our wishes, the Municipality (of Tokyo) and even some of my friends began to think of an American issue'. Mori feared that grave damage had been done to relations with the City of London, and further damage was caused when 'special

security' was demanded in London for foreign loans. In the event, a much abridged City of Tokyo Loan was issued in London; but by then the damage had been done. Although London figured in some of the Utility Loans needed to finance the huge demand for electrical generating capacity in Japan in the 1920s, most of the funds were raised in New York.

The last foreign loan was raised in London in May 1930 to repay the sterling loans of 1905 which were due. The same syndicate which had raised the 1924 Loan brought out a £12.5 million 5 ½ per cent Loan for the Imperial Japanese Government simultaneously with a $71 million Loan in New York.[3] A private placement by Schroders in London in 1931 raised £1.5 million for Nippon Electric Power.

The early 1920s were, indeed, years of stagnation for Japan, although there was some overall growth in the economy in the late 1920s. In 1927, Japan was the only major power which had not reverted to the Gold Standard. Heavy speculation in the yen resulted in heavy losses for exporting companies. There was a run on the banks, and in 1927 alone, 37 had to close; many of the weaker securities houses were also forced out of business and about one-tenth of Japan's bank deposits proved unrecoverable. Conditions for Japanese financial houses in the 1920s were difficult in the extreme. Natural disasters, the financial panic of 1927, and the American stock market crash of 1929 were followed by the World Depression.

Despite the reverses of the 1920s, four private sector Japanese banks extended their activities to London. The Sumitomo Bank was the first to open a branch at 67 Bishopsgate in 1918, followed by the Mitsubishi Bank in 1920, the Mitsui Bank in 1924 and the Yasuda Bank. All were closed down soon after the start of the Second World War. When the United Kingdom abandoned the Gold

Standard in September 1931, Japanese banks such as Mitsui became unable to settle their foreign exchange transactions between Britain and the United States and had to buy US dollars direct from the Yokohama Specie Bank.[4]

While there was some economic recovery in the 1930s, political liberalism in Japan became increasingly under attack from nationalist groups. Diplomatic isolation grew following the Japanese Army's actions in Manchuria in 1931. The Capital Outflow Prevention Act of 1932 and foreign exchange laws brought forward in 1933 were all indicative of the fact that financial policy was being increasingly subordinated to military objectives. In 1933, Japan left the League of Nations and, in the following years, abrogated the Washington Disarmament Treaty. In 1936, following a successful coup attempt, 'the February 26th Incident', the military's influence in politics became all-powerful. The stage was set for increasing alliance with Germany – via the Anti-Comintern Pact of 1936. War with China began within a matter of months, followed by military alliance with Germany and Italy, and the Pearl Harbour bombing in 1941 which brought the United States into the war.

THE POST-WAR RECONCILIATION

Understandably, Anglo-Japanese relations suffered from a legacy of bitterness and resentment following the end of the Second World War and the restoration of commercial and financial links was painfully slow. The American authorities then insisted upon some fundamental reforms in Japan's economic system. As part of a drive to ensure more plurality of economic power, family control (the old *zaibatsu*) was almost all swept away. Later, similar but much looser associations, *keiretsu*, were allowed to creep back into the system. A dividing line was drawn

between the banks and the major industrial groupings, and the banks were no longer to be allowed to participate in the securities field. The former *zaibatsu* names were prohibited for banks, so the Mitsui became the Teikoku Bank, the Mitsubishi Bank became the Chiyoda Bank, the Sumitomo Bank became the Osaka Bank, and the Yasuda Bank became the Fuji Bank. The Nomura Bank became the Daiwa Bank, and the Yokohama Specie Bank became the Bank of Tokyo, but most of these (not the Bank of Tokyo) were allowed to revert to their former names in 1952-4.

In 1947, the occupation authorities announced that private trade could resume, and an attempt was made to organise a syndicate in London to finance a £6 million credit to cover Japanese imports. This was blocked however by the British authorities, the Governor of the Bank of England objecting on legal grounds since Britain and Japan were still officially at war. This restriction lasted until 1950, when Schroders, together with the Hong Kong and Shanghai Bank renewed their original scheme. The Foreign Exchange Central Board, which handled Japan's currency reserves, accepted the proposal, together with a line of credit. Thus the London member banks were able to begin, once more, to provide credit to the Japanese authorities.

A team from the Japanese Ministry of Finance visited London in September 1950 and received a thorough reintroduction to the City of London's workings, particularly those of the money market. More help was given to the visitors in letters of credit to German bankers and Allied administrators in Germany. When representatives of the Bank of Japan arrived in 1951 to re-establish their office which had been closed since 1941, the Japanese presence in the City was restored. Schroders were particularly supportive in this process, helping the Bank of Japan to set up their

office. As the former's corporate history relates,[5] when Mr Yosuki Ono of the Bank of Tokyo visited London, he asked to see Schroders' balance sheet. He was politely told that Schroders, as a private partnership, opened its books to the Governor of the Bank of England and to no-one else. Helmut Schroder then invited Ono to Dell Park, where the latter was much impressed by the house and gardens, and on leaving told his host 'I have seen Schroder orchids – no need to see balance sheet'.

The Korean War, which began when the North Koreans invaded the South in June 1950, led to the liberalisation of many of the restrictions on the Japanese economy, which had become strategically important for the successful prosecution of that war. The Peace Treaty with Japan (The Treaty of San Francisco), signed in September 1951 and operative from April 1952, reopened the way to a fuller revival of the historic links, both diplomatic and financial.

As Japan's exports and imports grew, the volume of foreign exchange transactions increased sharply. In order to handle this growing business, the Japanese banks began to renew their overseas branch activities. In 1952, the Bank of Tokyo (successor to the Yokohama Specie Bank, and still the main agent for Japan's overseas finance) reopened its office in the City of London, in Birchin Lane. In that same year the Teikoku (formerly Mitsui) Bank reopened in the City, as did the Fuji Bank and the Mitsubishi Bank. The Sumitomo Bank opened its representative office in 1953 in Copthall Court; their motivation was variously described in a survey undertaken by the author in 1995. The Bank of Japan's aims were to investigate economic and financial development in Europe, to exchange views with European central banks and others on economic and policy developments, to monitor foreign exchange markets, to participate in international meetings and monitor Japanese banks (and later, securities firms) in the U.K. and Europe. The Fuji

Bank's original reason to open in London (its first ever overseas office) was to support their Japanese customers in Europe, and to establish an infrastructure to operate an international business. The Mitsubishi Bank, similarly, wished to be in a position to provide banking support to their Japanese corporate customers trading internationally, and to establish an international banking presence. The Sanwa Bank who had also opened their London office came because their major customers, mainly the Japanese trading houses, were already operating in London. The Bank of Tokyo's main task, initially, was to act as the paying agent for Japan's pre-war debt. These Japanese banks were strongly assisted in re-establishing themselves by London bankers – especially Schroders, the National Westminster Bank, the Hong Kong and Shanghai Bank, and Rothschilds.

By 1954, substantial sterling balances were again being deposited in London, in response to Japan's deficit with the Sterling Area countries. The Bank of England was supportive, and in, 1956, the Bank of Japan successfully negotiated an agreement in London whereby Japanese commercial banks could open full branch offices, and the Sumitomo Bank and the Mitsubishi Bank did so. The Bank of England gave permission for Japanese bankers to open sterling accounts which they did by advances from their London correspondents, but there was some unhappiness when at first the London banks involved insisted that half these sums be funded by the Ministry of Finance from their own foreign exchange holdings in London.[6] The Japanese were, as usual, meticulous in their treatment of the interest and principal on their outstanding foreign debt. The Bank of Tokyo handled the repayments, and as the European economies began their post-Marshall Plan revival, it was able to develop increasing trade finance in Europe from its office in the City of London.

The stage was being set for a real revival in the traditional close relationship at central bank and commercial levels, but Britain had refused to withdraw its opposition to Japan's membership of G.A.T.T., and this was very much resented in official Japanese circles. Feeling in Britain, stemming from the war, was still somewhat bitter, and there was much fear of Japan's export competitiveness. Nevertheless, the Japanese Chamber of Commerce in London[7] was established in the heart of the city in 1959, and there followed, in 1960, the conclusion of the Anglo-Japanese Cultural Agreement, and the first British post-war trade mission to Japan in 1961. Not until 1962 was a final Anglo-Japanese Commercial Treaty signed; but the stage was now set for normality, and in 1964 Japan was accepted with Article 8 status in the IMF and with Article 11 status in G.A.T.T. From 1964, Japan's links with the City of London were to develop rapidly, and on a much broader base.

LONDON'S RETURN – THE RISE OF THE EURODOLLAR MARKETS

London's role in the financing of the Japanese economy was dramatically restored by the emergence of the Eurodollar market. So limited was the London market before this development that in 1961 it was not found possible to issue a bond in London to repay the £23 million Japanese Sterling Loan of 1907 – and this had to be done in Switzerland. Indeed, as late as 1964, substantial loans were still being raised in that country and in Germany to finance Japanese infrastructural investment. Activity in London was more limited. The events of July 1963 were to trigger a major shift in the focus of activity to London, and to restore to the City, after a 50-year lapse, its former role as the main conduit for Japanese

fund-raising activity. The catalyst was the imposition by the Kennedy Administration in the United States of the Interest Equalisation Tax. Until 1963, Marshall Plan US dollars had increasingly become a source of finance for Japanese borrowers, but the activity was more centred in Paris and Rome than in London. The tax was imposed in an attempt to halt the tide of American capital moving overseas. Apart from restructuring capital outflows, the aim was also to insulate US internal interest rates from foreign influence. This measure could not stop substantial leakage in the system and there was a steady flow of dollars abroad from the US. 1963 also marked the year when the Japanese Government returned to London's capital markets with a £25 million listed Sterling bond, co-managed by Schroder Wagg, to finance the Japanese Sterling Bond of 1899; the City stockbrokers, Panmure Gordon, acted as brokers for the Japanese Government. The wheel had come full circle.

Until the early 1960s, New York had been for 40 years the centre of the international securities market. The early post-World War II moves by Japanese companies to raise capital abroad were via corporate debenture offerings by e.g. Kawasaki Steel and Sumitomo Metal. These were issued in US dollars in New York, underwritten and lead-managed by prominent American investment banking houses, such as First Boston, Morgan Stanley, Dillon Read and Kuhn Loeb. There were some equity issues, in the form of American Depositary Receipts — again in New York. The imposition of the Interest Equalisation Tax led these and other American banks to switch business to London. By 1964, the Euromarket had become a happy feeding ground for Japanese industrial borrowers, and by April of that year no less than twelve Eurobond issues had been made, all in London. Japanese equity offerings in British Depositary Receipt form were to follow, also

European Depositary Receipts, and Euro-dollar Convertible Bonds on behalf of C. Itoh, Takeda, Canon Camera,[8] Hitachi, Komatsu, Teijin and Toyo Rayon. London had become the main centre through which Japanese companies could raise new capital.

It was the advent of the London-based Eurodollar market, with its implications for the financing of Japanese industry in the mid 1960s that led to a major increase in the Japanese financial presence in London. By 1971, Japan had become the second largest foreign participant in the City of London with fourteen banks, five securities houses and nine insurance companies.

INVESTMENT AND JOINT VENTURES – OLD FRIENDSHIPS AND NEW

At first, the bulk of British investor buying of Japanese securities was channelled through investment trusts with large Japanese content. However, probably the earliest purchases of Japanese equities from London were made on behalf of King's College, Cambridge by their brokers, Vickers da Costa. Professor Nicholas Kaldor (later Lord Kaldor), who was running a large part of King's portfolio, insisted upon participation in Japan's growth. He had, since the mid-1950s, spent a month a year in Japan as a visiting professor and, by the end of that decade, was adamant that the country's progress was more than just a passing phenomenon. John Clay, then an analyst at Vickers,[9] did some research, established contact with a Japanese broker, and some investment positions were established.

There were, in 1960, severe restrictions on buying Japanese shares, including the seven-year rule whereby money invested could not be repatriated for seven years; switches between holdings re-started the seven-year clock. Kaldor pressed for an investment trust medium, in order to

achieve some secondary market liquidity. Accordingly, in February 1961, Vickers set up a fund to invest in Continental Europe (75 per cent) and Japan (25 per cent), but this did not go far enough for the professor's requirements and so in November 1961, Ralph Vickers, the senior partner, was persuaded to set up the Anglo-Nippon Trust, a $10 million closed-end fund, solely for investment in Japanese equities and the first of its kind.

There was much scepticism at the time, and nearly all the early subscribers were Oxford or Cambridge colleges, with none of the conventional institutions in London or Edinburgh participating. Clay's recollection is that the only 'outside' initial investor was a Scottish whaling company which had been driven out of business by Japanese competition. Clay thus found himself managing the first public vehicle anywhere in the world to invest exclusively in Japanese securities. It was listed on the London Stock Exchange.

Clay was later to be closely involved with some of the initial Japanese offerings in London, writing the prospectuses and advising the companies concerned. In 1968 Vickers also set up The Nippon Fund, the first offshore fund for investment in Japan, with Clay as investment manager. Vickers was followed by James Capel, Cazenove's and W.I. Carr in establishing specialist Japanese departments and capabilities. All this activity added impetus to the efforts of the Japanese brokerage community. N.M. Rothschild also set up, in partnership with Merrill Lynch of the US and International Pacific Corporation of Australia, The Pacific Seaboard Fund, an offshore fund and Nomura joined that partnership as investment adviser. In early 1969, Robert Fleming & Co established the Fleming Japan Fund, a Luxembourg-registered offshore fund. In April 1970, the first standard British unit trust specialising in Japanese securities was set up, by Robert Fleming & Co's Save and

Prosper Group, and is still in existence as the Save & Prosper Japan Growth Fund. By the early 1970s other major investment groups such as Henderson Administration and GT Management were making strategic investments in Japanese equities.

The first Japanese consortium bank in London, The Associated Japanese Bank, was established in 1970 by the Mitsui, Sanwa, and Dai-Ichi Banks, with Nomura Securities also participating. This joint venture bank was designed to raise funds largely on the Eurodollar markets, and to operate these funds for long-term corporate financing and for securities-related business. The establishment of this bank attracted wide interest in Japan.[10] In the same year another similar bank, Japan Bank International was also established in London, ostensibly designed to raise medium and long-term finance for Japanese companies. The Mitsubishi Bank, in 1971 joined an existing London consortium (Orion Bank), and the Sanwa Bank soon afterwards acquired a stake in the Commercial Continental Bank. The Sumitomo Bank joined a consortium with Credit Suisse White Weld in London, and Sanwa established a joint venture with Barings in 1973, in which year another joint venture was established, between the Mitsui Bank and Hambros Bank (Hambros-Mitsui Ltd), to conduct business in securities underwriting, financial mediation and consultancy services. In 1973 also, a similar joint venture merchant bank was formed by the Fuji Bank and Kleinwort Benson (Fuji Kleinwort Benson Ltd.), with Mr Toru Hashimoto, now President of the Fuji Bank and Chairman of the Federation of Bankers Association in Japan, as its first Japanese Joint General Manager. The Tokai Bank had a similar linkage with the Kiowa Bank and Morgan Grenfell in 1974. In the course of time, these joint ventures became the securities subsidiaries of the Japanese banks concerned, as the latter bought out their British

partners. Thus, typically, in 1977 Fuji Kleinwort Benson Ltd became Fuji International Finance, Ltd.

On a more official basis, the renewal of old friendships was strongly confirmed by the State Visit, in October 1971, of the Emperor of Japan and the Empress. This was regarded as a fitting symbol of the restored relationship, and of the growing commercial and financial representation in Britain. In his speech at the State Banquet in Guildhall, His Majesty Emperor Hirohito stated, 'The Japanese people have always looked up to the City of London . . . as the depository of financial and commercial expertise and observed, with wonder and respect, its indomitable spirit of freedom, strict code of gentlemanly conduct, and courage to make a startling departure from old practices as occasion arises.' He received a standing ovation.

CHAPTER 3

Globalisation From 1960

Global Banking • The Japanese Brokers Focus On London • The Japanese Expand Into The Euromarkets • And The Rise Of The Euroyen • London's Competitive Markets In The Mid-1980s • Difficulties With Banking Licences In The 1980s

GLOBAL BANKING

The expansion of international banking and securities markets gathered pace very strongly in the 1960s and 1970s. In the case of banking this was partly the result of the increase in world trade and foreign direct investment. It was also partly a function of the increased sophistication of information technology, global communications and innovation of financial products. Although United States banks led this expansion, together with Canadian banks the Japanese were next to follow. In 1962 there were only 62 foreign banks with branches in London; by 1981 there were 229. New York, too, was a favoured location for foreign banks because of the huge economic hinterland of the United States and the leading part which the US dollar was now playing in international payments. However, the

Federal Reserve Bank's restrictions on the use of the dollar abroad led, largely by default, to the use of the Euro-dollar market, and London quickly established itself in the 1970s as the main centre for Euro-dollar based activities. The use by Japanese corporations of the Euro-dollar markets was much affected by the archaic and restrictive markets at home. Borrowing abroad was therefore highly attractive.

A significant part of the assets held by Japanese bank branches abroad have naturally been claims on residents of Japan, or on corporations headquartered in Japan. The growth of Japanese foreign direct investment in the United Kingdom was therefore a strong stimulus to the establishment – and growth in scale – of the Japanese banking presence in London. It is interesting to note that by the mid 1980s, while the growth of international bank branches in London was slowing down generally, activity by Japanese banks was still increasing. The larger banks were relying more on their overseas branches to fund their own lending at home. In the 1980s Japanese exports in general were increasing rapidly, along with direct investment abroad. Naturally, Japanese banks expanded equally rapidly abroad, armed as they were with enormous capital resources. They were the main conduit for the recycling abroad of the huge surpluses accumulated as a result of the very large positive trade balances and rate of savings. Japan's strong stock market and real estate market also contributed strongly towards the funds available for expansion. The growth of the Japanese banking presence in London was dramatic, and by 1983 it was estimated that the share of Japan's international banking business taken by the London market was as high as 38 per cent. Although this figure was to decline, Japanese banks continued to increase their share of Britain's total banking assets (see tables).[1]

In 1986 the Japanese Offshore Market was established for non-domestic transactions, though restricted to authorised

Table 3.1 London's Share of Japan's International Banking Assets

	($ billion, end of year)				% Increase 1983-9 (- Fall in share)
	1983	1985	1987	1989	
Total International Assets of Japanese Banks of which:	451	706	1291	1967	336.1%
Japanese Banks in London*	172	246	363	461	168.0%
% London Share	38%	34%	28%	23%	(-15.0%)

* Includes claims on offices in Japan.

Table 3.2 Japanese Banks' Share of London's Business

(Sterling and other currencies) – expressed in £billions.				
	1975	1979	1984	1989
Total Assets of Banks in UK (£bn) (Oct) of which:	138.7	263.8	759.6	1,233.6
Japanese banks	11.8	29.2	167.4	282.0
% Japanese share	8%	11%	22%	22%

foreign exchange banks. This market was freed from reserve requirements, interest rate controls, deposit insurance and withholding taxes. Transactions could be made with foreign banks and securities firms, governments and corporations, but specifically not with foreign individual clients or the overseas branches of Japanese non-financial corporations. These measures, and, in part the lower profitability of banking in Japan as a result of deregulation, further encouraged overseas branching by the Japanese banks. Large multi-national companies are key customers for banks offering international services. The Japanese multi-nationals expanding in Europe directed the lion's share of their investment into the United Kingdom (overall about 40 per cent of all EU investment from Japan). It was, therefore, natural for Japanese banks to favour London

as their European headquarters. The larger Japanese banks also looked increasingly to their foreign branches to fund their domestic lending because their foreign activities were deregulated more rapidly than were deposits of banks in Japan.

A study in 1992[2] of the overseas offices of the world's largest 1000 banks, ranked by assets showed the following European locations for the Japanese banks:

UK	39
Switzerland	19
Germany	18
France	12
Netherlands	10
Spain	10
Italy	6
Other W. Europe	22
E. Europe	0

In the same context the locations for those 1000 banks as a whole were:

UK	257
Germany	96
Switzerland	92
France	70
Spain	68
Italy	43
Netherlands	41
Other W. Europe	143

By 1993, the world's largest 1000 banks had 2561 offices overseas. Japanese banks owned 434, of which 39 were in London, and 42 in the USA as a whole. Within Europe, 19

were in Switzerland, 18 in Germany and 12 in France. The Bankers' Magazine published in November 1994 reported that there were then 47 Japanese banks in London.

The City Research Project Study *The Growth and Structure of International Banking*, published in July 1994,[3] contained fascinating data on the correlation between overseas banking and trade, as well as that between foreign bank presence and foreign direct investment. In the latter case, it noted that, in the location overseas of Japanese banks, foreign direct investment was a particularly strong factor. The study also showed that the GDP of the parent country is much more important than that of the host country. This, of course, is relevant to the fact that the UK has attracted many more Japanese banks than Germany, notwithstanding the fact that German GDP is very much higher than that of the UK. The definition of an international financial centre was given as 'one which attracts foreign banks to access its capital markets rather than to support international trade'. Thus, the Study pointed out, London's clear superiority as an international money centre has been an important attraction. The presence of many foreign banks in Germany, France, Italy and Spain can be explained by the size of their economies and their trade. Switzerland on the other hand, as an international financial centre, attracted more Japanese banks than any other European centre except London.

THE JAPANESE BROKERS FOCUS ON LONDON

The events of 1963 had a further significant outcome – they led to the establishment of the 'Big Four' Japanese stockbroking firms in the City of London. The imposition of the Interest Equalisation Tax (in effect a tax on US ownership of foreign securities) meant that Japanese brokers in the US found that their business of selling Japanese

stocks to Americans was virtually brought to a halt. London was to become their focal point for expansion overseas. Nomura Securities was the first to arrive, in March 1964, with a representative office in Gresham Street. Yamaichi Securities was to follow, to Philpot Lane, Daiwa Securities to Queen Street, and Nikko Securities to Cannon Street. Because Japanese banks were forbidden to participate in the wave of Japanese Euro-dollar issues in London, it was the Japanese securities houses which took part, although, at first they played a secondary role as co-lead manager or co-managers. The lead manager was invariably a large American or British firm.

British firms hesitated at first in dealing with these Japanese firms direct, since the latter dealt on their own account quite substantially (a practice forbidden to British brokers) and there was an understandable fear of conflict of interest when advising or dealing for clientele. The salesmen which these Japanese firms imported from Tokyo found life far from easy, and even lonely.

In 1964, fewer than 2,000 Japanese were living in London. Many of the brokers' salesmen spoke no English and had come without their families. The one Japanese school in London attracted those with families to settle in Hendon and Finchley, an area which was to become described as 'Little Tokyo'. South Croydon was also a favourite dormitory area for the new arrivals. One Japanese restaurant in central London, Akiko, and one Japanese club were just about the only leisure centres where they could feel at home. Life was often hard, and it is recorded that Nomura's hard-working salesmen were at first only given £100 a month for living expenses.

The British financial community in the 1960s still had unhappy and often resentful memories; for many senior British bankers and brokers had suffered in prisoner-of-war camps in the Far East during the Pacific War, or had

lost close friends and relatives. Some even refused, at first, to deal directly with the Japanese. That hostility was, however, compensated for by the helpfulness of many institutions, especially the Bank of England, and by the personal friendships that were to be established or revived with leading banks such as Rothschilds and Warburgs. These and others, together with brokers such as Vickers da Costa, Nathan & Rosselli, James Capel and Panmure Gordon already had friendly ties with Japanese counterparties.

Miss Haruko Fukuda can be regarded as one of the most distinguished and experienced doyens of the Japanese financial community in London. She joined Nikko Securities in London in 1988 but her father, as Minister Plenipotentiary at the Embassy of Japan, had been the regulator responsible for the coming of the Japanese brokers to London. She was the first Japanese, and the first woman, to join the Board of the Foreign and Colonial Investment Trust. In a lecture to the Japan Society in March 1994, she traced the history of the Japanese securities houses in London, reminding us that it was exactly 30 years since the 'Big Four' (yon dai shoken) opened their doors in the City. Later, smaller Japanese brokers such as New Japan, Wako and NKK Securities were to follow their larger compatriots.

'The Japanese brokers made strenuous efforts in the 1970s to establish their own credibility and sought ways to deal direct with British Institutions', she told her audience. 'They began sending research literature of varying quality because foreign institutional investors placed much importance on fundamental research and it was in this area that British brokers had the upper hand.'

A young British institutional fund manager told the author that when he visited Tokyo in the early 1970s, he took great care not to let any Japanese brokers know

in advance, so as to avoid their persistent and sometimes embarrassing attentions. However alert watchers at Tokyo airport had clearly spotted him, for no sooner had he checked in to his hotel than the front desk rang to tell him that two gentlemen from Yamaichi Securities were waiting from him in the lobby and had a large parcel for him. Knowing the generosity with which institutional visitors were traditionally regaled, he decided to return the compliment by presenting each of his visitors with a bottle of Johnnie Walker Black Label whisky, which he had brought with him as gifts. Scotch whisky of such quality was, he knew, highly prized in Japan. The exchange was duly made in the hotel lobby, the two Yamaichi representatives expressing great delight and profuse thanks before bowing deeply, chattering to each other excitedly as they left. Two porters then delivered the large, beautifully wrapped and be-ribboned parcel – it was a small crate – to the Englishman's room. He unwrapped it with high expectations, but found, to his chagrin that he had exchanged his only two bottles of Black Label for the entire printed output of Yamaichi Securities' Research Department for the past year.

Language, according to Miss Fukuda, was a particular problem for the Japanese salesmen and many of them relied on their smiling personality to win friendly clients. Some brokers such as Nomura tried to demonstrate that institutions as final clients were more important than the brokers by seating the brokers at the bottom of the table at information meetings they organised, and a certain amount of tug-of-war between the British brokers and large Japanese brokers became noticeable by the late 1970s. This became much more of an issue when the secretive investors of the Middle East began to put very large sums of money into Japan through the British brokers in 1979. However, as Miss Fukuda related:

'There was a certain amount of tension but on the whole the Japanese brokers recognised the volume of orders that could be got from their British competitors and business flourished in close friendship as the client base expanded rapidly following the removal of exchange controls in Britain in 1979 with the advent of Mrs Thatcher's government.'

THE JAPANESE EXPAND INTO THE EUROMARKETS
AND THE RISE OF THE EUROYEN

The process of liberalising Japan's overseas investment was slow. As we have already seen, the rapid post-Korean War expansion at home required nearly all the available domestic resources in spite of the high savings rate.[4] Very few licences were granted for the export of capital in the 1950s and early 1960s. There were severe restrictions on any form of investment in overseas securities, and Japanese financial institutions could not take part in bond issues abroad or lend to borrowers.

Only in 1970 were Japanese investment trusts allowed to acquire any foreign securities, and permission was limited to $100 million per institution. Further liberalisation followed the very next year, and the biggest securities houses themselves established international investment trusts. This was followed by a lengthening of the list of approved foreign securities, with permission for them to be traded over-the-counter in Japan. In 1973, the first six foreign companies achieved full listing on the Tokyo Stock Exchange. By then, eight Japanese corporations were listed in ADR form on the New York Stock Exchange, and the first Samurai Bonds appeared; these were yen-dominated bonds issued in Japan by foreign governments, public agencies and corporations. Japan was now playing a full part in the internationalisation of securities markets.

The Japanese Government now proceeded to reverse its previous policy of discouraging the use of the yen as an offshore currency. The use of the Euroyen – yen deposits in Europe – grew after 1975, deliberately encouraged by the Japanese Government. The way was now open for Euroyen bonds to be issued in London, displacing Samurai bonds. Japanese brokers had been pressing for a Euroyen market to be allowed to develop. Daiwa Securities, in particular, had been prominent in this lobby, and they and S.G. Warburg jointly lead-managed the first Euroyen bond issue in 1977; this was followed by many others. S.G. Warburg had assiduously developed its Japanese contacts in London and Tokyo for many years, had forseen the development of the Eurodollar market, and was well positioned to attract Japanese clients to it.[5] As a contemporary issue of 'Euromoney' magazine noted:

> 'According to the Japanese bankers themselves, the issue and its successors represented the first time . . . that a national government has proposed to use the market as a deliberate instrument of national financial policy, and to control its currency's sector of the international financial scene.'

By 1980, just under 4 billion yen had been deposited in Europe, mostly in London. This activity was further supplemented in 1981 when the commercial code was changed to allow Japanese corporations to issue Eurobonds with equity warrants; again, London was the centre of activity. The first such issue was by Mitsubishi Chemicals in 1982. As the Japanese stock market boomed in the mid and late 1980s, a flood of such issues followed. Daiwa and Nomura were foremost among the Japanese securities houses in the growth of this market, and the secondary market for these warrants in London was extremely active

in these years. In 1985, more money was borrowed in the Euroyen market than in the domestic market in Japan. As we shall see, Japanese brokerage houses in the City became overwhelmingly the top lead managers for such issues, Nomura to the fore. This huge new market gave further scale to the Japanese profile, if not dominance, in the Euromarkets. By 1988, borrowings in the Euroyen market had reached $21.7 billion, not all for Japanese borrowers. In that year, no less than fifty-eight Japanese securities houses had offices in London, a figure which represented 30 per cent of all foreign securities houses in the City. Of these fifty-eight, fourteen had seats on the Stock Exchange in London. The second-rank securities houses were now present in strength, and had been joined by the financial affiliates of Japanese trading houses and insurance companies. Overall, the securities houses had more employers than all the Japanese banks in London, with a higher proportion of non-Japanese employees.

LONDON'S COMPETITIVE MARKETS IN THE MID-1980S

Increasingly in the 1980s, as non-Japanese global investment firms developed their own expertise, Japanese financial institutions in London and elsewhere were faced with increasing competition. Active markets in London for Japanese securities with relatively low dealing costs, led to a considerable loss of market share to non-Japanese competitors. Further, the relatively high costs of operating in the Tokyo market made Japanese investors and companies aware of the attractions of other stock markets – indeed this trend continued into the next decade; in 1985, the Japanese were to play a key role in the successful Privatisation offer of British Telecom shares, then the largest stock offering in history. No less than 180 million shares were allotted to the Tokyo market,

Nomura having been selected to lead-manage that tranche and joining Morgan Stanley and Kleinwort Benson as one of the three global lead-managers.

Big Bang, in 1986 brought the Japanese stockbrokers, in Miss Fukuda's words 'ultimate recognition, and new challenges.' The establishment in London of the International Stock Exchange in lieu of the old London Stock Exchange brought in foreign participants, and especially those active in the Euromarkets. Japanese nationals became for the first time, members of the Council of the Stock Exchange[6] – American and continental European houses added to the capital investment in London which followed, in many cases as global players. The Japanese, however at first adhered to the business they knew best, servicing British and European institutions in Japanese issues, and advising on the Japanese economy. They did, in due course, participate as underwriters and sub-underwriters in an increasing amount of non-Japanese issues, and established themselves in the primary Eurobond market because of their ability to place stock with their clients in Japan.

In Japan, no broker can offer banking services or own a bank under the Securities Exchange Law, but these brokers saw, in London, some profitable synergies in banking activities to complement their securities businesses.[7] They did not attempt to compete with Japanese banks in term lending, but rather saw a banking base as a useful adjunct to their underwriting activities, as a medium for foreign exchange capability, and as a springboard for investment banking in the future. The establishment of such subsidiaries in London was further evidence of its attractions, of the sensible regulatory climate, and of the availability of skilled labour in the City.

The value of London as a financial skills-learning centre has been the subject of wide comment. Dr Andreas Prindl, now Chairman of Nomura Bank International

plc described the reasons why Nomura selected London as the preferred location for their European expansion into banking services in the early 1980s as follows:

> 'London was considered the best location for the new Nomura banking venture. London is the cockpit of international finance. Its magnificent infrastructure of banking, insurance, and commodity markets is unrivaled in Europe. The City also has a tradition of welcoming and offering freedom of access to foreign institutions that wish to participate in its financial markets. Regulation of the banking section is intelligent and flexible, and securities regulation has been rather loose until recently. Exchange control was abolished in 1979. Not only is the regulatory and structural side attractive, but London also has a large pool of trained labour, both managerial and clerical, in the financial sector. English is the language of world finance. Although demand for good banking space has outstripped supply, causing very high rentals, and the telephone system is mediocre, London has generally good communications. For all these reasons, it is the prime location. Indeed, one cannot function in international banking without a London base.'

The protracted negotiations over the licensing and regulation of London-based banking subsidiaries by the leading Japanese brokers is described elsewhere in this book. The first of these, Nomura International Finance plc. opened as a licensed deposit taker November 1986; and was followed by similar moves by the other three leading brokers over the subsequent two years.

In the wake of Big Bang in 1986, London's usefulness as a training ground for non-British banks, especially American and Japanese became well established (in both

countries, their banks were debarred from securities business). Indeed, London with its innovative culture, tradition of internationality and relative lack of regulation was becoming, for many foreign institutions, a useful test-bed for new types of financial instrument. These characteristics, combined to make the City of London the centre of choice for Japanese financial houses in Europe.

Another measure of the scale of Japanese financial involvement in London in the late 1980s was the extent of participation of the Japanese banks. The Bank for International Settlements' figures for international bank lending in 1986 showed that the Japanese banks were responsible for about one third of the total – and about one third of that figure was booked in London; in that year they also handled about 15 per cent of all interest-rate swaps in London by value. In 1987 they held assets in London representing about 35 per cent of all international assets in Britain, borrowed 22 per cent of all Eurobond money raised in London, dominated the market in Euroyen transactions, and were exceptionally prominent in Floating Rate Notes. The Japanese banks also built up in those years a fairly substantial business in foreign currency lending to British institutional borrowers, especially in financial and other services, including Local Government.[8]

DIFFICULTIES WITH BANKING LICENCES IN THE 1980S

The UK Banking Act of 1979 came into effect in 1980, with the requirement that any British-based bank owned by an overseas financial institution be regulated by the legal and competent authority in that institution's country of domicile. This delayed the ability of the major Japanese securities houses to apply for UK banking licences since, whereas those houses were responsible legally to the

Securities Bureau of the Ministry of Finance, it was the Banking Bureau of that Ministry which was the competent authority for banking purposes,[9] and the latter had no enthusiasm to undertake such supervision if by so doing it created direct competition for existing Japanese banks.

The British Government, and indeed many in the City of London were becoming concerned about Japanese overrepresentation in London; by 1985, no less than twenty five Japanese houses were already authorised to offer banking services in the UK. The situation was further complicated by the question of reciprocity, since the Japanese authorities were, at the time, very reluctant to allow more British financial houses to engage in securities business in Japan or to become members of the Tokyo Stock Exchange. This question of reciprocity now became a political issue, in which the Prime Minister, Margaret Thatcher, became involved, as did Michael Howard then a Trade Minister at the Department of Trade and Industry.

In the 1970s, the Bank of Japan and the Ministry of Finance had been helpful in allowing British merchant banks to establish offices in Tokyo, but neither British banks nor brokers could deal on the Tokyo Stock Exchange. Not until 1982 was Exchange membership allowed for foreign companies, but this was purely nominal since, at the time, the eighty four Tokyo seats were fully taken by Japanese firms, and none was left available for foreigners. This situation led to protests from both the British and United States governments.

The Japanese securities houses who wished to gain banking licences in London were being joined in this aspiration by many regional secondary Japanese banks who wanted to come to London for prestige reasons, and so as not to lose their local Japanese customers. The Japanese Ministry of Finance was keen to encourage this, and, moreover, there was a growing desire by the major banks,

especially the Industrial Bank of Japan, to open securities subsidiaries in London (prohibited in Japan).

Whereas the Americans threatened sanctions and pursued 'trade-off diplomacy', the Bank of England, in considering applications for banking licences, was bound by the provisions of the Banking Act which set out specific criteria for the assessment of such applications (quality and experience of management, proposed business and income streams, etc.) and ruled out the possibility of direct trade-offs on a reciprocal basis. So far as Japanese securities houses were concerned, moreover, the Bank of England had to be satisfied that banking subsidiaries established in London would be adequately supervised by their home authorities. In practice, not only did the processing of individual applications necessarily take time but, in order to avoid a large, simultaneous, and potentially destabilising influx of new institutions into the London market, the Bank of England operated an informal queuing system whereby the number of new entrants to the market each year, of whatever nationality, was limited. It was believed by some that pressures from British politicians led to further delays.

As a result of an initiative taken by the British Chancellor of the Exchequer at the time, Mr Nigel Lawson, and the Japanese Finance Minister Mr Takeshita (later to become Prime Minister) a regular series of meetings at official level (the Anglo-Japanese Financial Bilaterals) began in the mid-1980s. On the British side, the talks were initially led by Sir Geoffrey Littler, Permanent Secretary for Overseas Finance at the Treasury and the British team also included representatives of the Bank of England and the Department of Trade and Industry, which was, at the time, responsible for financial services.

These meetings became the principal forum for discussion (and in many cases, the resolution) of outstanding bilateral financial issues between the two countries. One

of these issues was membership of the Tokyo Stock Exchange and indications that Japanese participation in London might be limited in some way, together with US 'level playing field' pressure, led, in 1985, to the Tokyo Stock Exchange announcing with MOF approval, that six foreign firms were to be admitted to the Exchange for the first time. Of these, three were British, namely Warburgs, Jardine Fleming and Vickers da Costa, and three American – Goldman Sachs, Merrill Lynch and Morgan Stanley. The inclusion of Morgan Stanley was significant in that it was a major participant in the substantial volume of Japanese warrant trading in London at the time.[10] There had been no less than twenty applications for the six seats in question. There was still some continuing tension, and this led, within the next two years, to a second round of approvals allowing three more foreign firms to have seats on the Tokyo Exchange, including Cazenove & Co.

In the Bilaterals, each country put its specific concerns on the table; in particular, from the Japanese stand-point, the focus was on the granting of banking licences in London to Japanese regional banks and to subsidiaries of the big Japanese securities houses. The British side sought increased access to Japanese financial markets, especially in the securities field. In the earlier meetings, the politicisation of some of the issues, notably membership of the Tokyo Stock Exchange, led to tensions in the bilateral relationship. However, as the major problems were resolved, these frictions disappeared. Input to the UK agenda for the Bilaterals was provided by the Japan Committee of the British Invisible Export Council, established in 1985. This brought together representatives of the Bank of England, the Treasury, the DTI, the FCO and practitioners in financial markets, and it developed as an important forum for liaison between the official and private sectors on outstanding financial issues.

The Bank of England's concern over adequate supervision was resolved when it concluded, in early 1986, an agreement with the MOF in Tokyo whereby the latter's Securities Bureau and Banking Bureau undertook joint responsibility for supervising a bank in London opened by Nomura (Nomura International Finance) and, in September of that year, Nomura's application was approved by the Bank of England. Applications by the other three members of 'The Big Four' Japanese brokers were approved at carefully phased-in intervals over the next two years, and Daiwa and Nikko followed, with Yamaichi establishing their bank in 1988. It is interesting to note that Nikko Banking plc was established as a British-constituted bank under the regulatory supervision of the Bank of England.

As outstanding issues became increasingly resolved, so the bilateral talks became less frequent;[11] they had progressively developed in a more friendly and constructive atmosphere, and the end-result was regarded by both parties as satisfactory.

CHAPTER 4

After Big Bang
The Late 1980s And A Wave
Of Japanese Investment

The Impact Of Japanese Direct Investment • Investment By Japanese Life Insurance Companies • Japanese Property Investment In London From 1985

AFTER BIG BANG

The choice of London as a location was strongly influenced by British financial deregulation. Big Bang in 1986 opened up the London market for foreign participants in a dramatic way, and the Bank of England performed a powerful enabling and encouraging role in helping foreign banks and securities houses to participate in London's financial markets. One of the greatest attractions to overseas banks, therefore, was the relative ease of access to domestic banking markets in the United Kingdom – in marked contrast to the rest of Europe. The effect can be seen in today's statistics which show that, in the UK, overseas banks are responsible for about 30 per cent of

total commercial lending; in Germany the figure is 4 per cent.

Although sterling's role had shrunk very considerably as a medium of exchange internationally, London, as the centre for Eurocurrency business, and as Europe's only multicurrency market centre of any stature, successfully attracted ample business in currencies other than sterling. A strong influence was undoubtedly the preference of corporate customers to deal in the London Foreign Exchange market because of superior liquidity and better information flow than elsewhere. Centralisation and concentration of resources, by reducing costs and aiding control, were increasingly recognised as an economic imperative. The preference by corporations for dealing with a single bank to handle international requirements on a global basis was another key factor. London's relative lack of regulation and other historic attractions helped it become the clear leader in primary and secondary Eurobond markets, and Japanese banks were among the dominant operators. London's welcome to overseas entrants and its historical market ethos was not in fact new. Over the centuries, the long-term characteristic of London, in contrast to Continental European centres has been its openness to foreign entry. It was, in a way, therefore, natural that London should assume the role of Europe's multi-currency centre.

In the 1980s further giant strides in information technology, a wave of financial deregulation and the huge expansion in global financial flow led to a growing level of cross-border transactions; London was now set to become the main market for liquid instruments internationally, and the dominant market in foreign securities. By 1987, London was by far the most important centre for Japanese financial activities in Europe. Their houses were playing a major role in the City's international – and domestic business. Japanese institutions accounted for 26 per cent of

all banking assets in the UK and 25 per cent of interbank transactions. Four of the top five Eurobond lead managers in 1987 were Japanese. Article 65 of the Japanese Securities Exchange Law, prohibiting institutions from both lending and underwriting in Japan had led them to enter fields abroad closed to them at home. In 1987, the Japan Working Group of the British Invisible Exports Council estimated that Japanese financial houses employed about 2,000 Japanese and perhaps as many as 12,000 British staff in the UK.[1] In that year Nomura hired Oxbridge graduates, and other houses were beginning to follow this example. The Japan Working Group also estimated that these firms indirectly contributed roughly £700-£800 million indirectly to the British economy. In 1989, the big four Japanese securities houses were at the very top of the league of Eurobond lead and co-lead managers. Nomura, Nikko, Daiwa and Yamaichi together accounted for 39.74 per cent of all new issues (up from 23.43 per cent in 1988).[2]

The emergence of the City of London in the mid-to-late 1980s as the financial epicentre of Europe and the main base, in the European time zone, for Japanese financial houses of all kinds, undoubtedly enhanced the attraction of Britain to Japanese commercial and industrial investors. It was becoming the favoured recipient, in Europe, of direct investment from Japan as it already was from North America.

THE IMPACT OF JAPANESE DIRECT INVESTMENT

The strength of the Japanese banks, their commitment to London, and their preparedness to establish themselves there to support their customers were all key factors leading to Japanese direct investment in Britain. The first Japanese industrial investment in the United Kingdom

started in the early 1970s, when a zip fastener factory was established in Runcorn; then Sony responded to a suggestion by the Prince of Wales that Wales would welcome Sony. Panasonic followed – again to Wales. The Department of Trade and Industry had to make deliberate efforts to encourage Japanese industry to ignore quite a strong anti-Japanese mood in British industrial and trade union circles, and in due course Hitachi opened a factory in the North-East, followed by a range of Japanese consumer electronics companies, together with some of their component suppliers. The automobile industry followed – Nissan in Sunderland, Toyota in Derby, and later Honda.

As these, and other major corporate clients of the Japanese banks established a presence in Britain, so those Japanese banks not already represented in London became more anxious to have a presence there, so as to retain those clients' overseas business, especially as the UK was attracting the lion's share of Japanese investment in Europe. Conversely, the very strength of London as a centre of excellence in financing, accountancy and insurance was of itself an attraction for Japanese direct investors in the UK.

The scale of this investment increased rapidly in the 1980s, in line with the growth of Japan's current account surplus, which in 1985-9 totalled $350 billion. In 1989 alone Japan's long-term capital exports amounted to $192 billion. Japan had become the world's largest exporter of capital, and the world's largest creditor. Undoubtedly, the sharp rise in the yen against other currencies played a major part in setting so much outside investment in motion. The JETRO analysis[3] in 1993 showed that Japanese manufacturers' overseas production, as a percentage of their total, rose steadily from 3.0 per cent in fiscal 1985 to 5.7 per cent in fiscal 1989.

In the early 1980s, the United States was the main recipient, but by the latter half of the decade, the focus

had shifted to Europe, which was absorbing $9-$10 billion of Japanese investment per annum, with the UK being the consistent favourite. Between 1984 and 1991, the stock of Japanese inward investment in Britain increased by over 580 per cent.[4] A survey by JETRO showed that, by 1992, Japanese manufacturers were responsible for more jobs in the United Kingdom than in France, Germany and Italy combined. Moreover 54,000 Japanese were living in the UK, with over 1,000 Japanese companies active here. Of these, 200 were manufacturing in 270 plants, most heavily concentrated in automobiles, electrical appliances, and high-technology products. A recent estimate showed that, by 1995, Japanese companies in the UK employed directly over 80,000 personnel. In spite of the recession in Japan, and difficult trading conditions in automobile markets internationally, such investment has continued; in September 1995, Nissan announced a further investment of £250 million, bringing their total UK investment to £1.25 billion.

This substantial commitment was celebrated by the then Japanese Ambassador in the U.K., H.E. Hiroshi Kitamura, in a series of speeches in 1992 and 1993. The following extracts are notable:

'Let me examine the causes of the huge increase in Japanese direct investment into the UK that took place in the latter half of the 1980s. The drastic appreciation of the yen, which started in 1985, and the need for measures to ease trade friction, made it necessary for Japanese companies to adopt a global strategy, including the transfer of production operations overseas. Moreover, the impending single market in the EC made them apprehensive about the possible emergence of a 'Fortress Europe' and prompted them to set up production and marketing bases in Europe.

So why did Europe prove to be such a pull for Japanese investment? It was not just because the Anglo-Japanese relationship was the closest of any bilateral relationship between Japan and an EC member country. I think there are four factors which played an important part. First, there is the English language, the most accessible foreign language for most Japanese people. Secondly, there is the infrastructure reflecting Britain's status as an industrial nation of long standing – particularly in the financial field, as symbolised by the City. The third factor is the availability of a high-quality, diligent and productive labour force at a relatively reasonable cost. Finally, there is the welcome shown by the British Government as well as by local authorities and communities to Japanese inward investment.

When I look back to the three years I spent here in the mid-sixties, I recall that it was just after our two countries had signed the first bilateral treaty of commerce, trade and navigation following the war. At that time, the idea of Japanese direct investment in the UK would have been the stuff of dreams. There were fewer than 1,000 Japanese living in London and, needless to say, not a single Japanese restaurant. By contrast, today there are 54,000 Japanese living in Britain, and more than 1,000 Japanese companies active here. Moreover, in London alone there are close to 100 Japanese restaurants. Exchanges between the two countries are flourishing on every level, with 530,000 Japanese having visited the U.K. last year.

I see no reason why Britain should not remain the most favoured location for Japanese investment in Europe, as long as the factors which have attracted this investment remain in place.

I have often referred to four main factors in this regard and I think it is worth repeating them here and now.

First, there is the English language, the most familiar foreign tongue to Japanese people. Second, there is the availability of good-quality labour at a competitive cost. Third, there is Britain's sound infrastructure in terms of telecommunications and transportation, and especially the financial services provided by the City of London. The fourth factor consists of the generous welcome given to Japanese direct investment by government, at central and local level, as well as by so many people involved throughout the United Kingdom.'

In February 1994, ahead of my forthcoming visit to Japan as Lord Mayor of London I made a presentation at the Savoy Hotel, organised by the JIJI Press, to an audience of eighty Japanese journalists and businessmen. I reviewed the reasons why so much investment had come to Britain as follows:

'Why is this ? Why have they come here ?

Firstly, these are free market decisions, not political decisions like the siting of the EMI in Frankfurt. They have shown their confidence in our long term future. The reasons they have come are clear and are: the English language; good distribution networks and manufacturing infrastructure; excellent availability of supplies; very importantly, a large sized, good quality, high output and low cost work force with liberal labour regulations; there are no exchange controls on profits sent overseas and we have the most favourable business tax rates in Europe; an attractive domestic market and importantly, political stability.

We give Japanese investment in the UK a warm welcome. We are a champion of it in Europe. Britain is the preferred stepping stone into Europe for those investors outside the European Union. There is no doubt that

Japan attaches great importance to London as the hub of the European capital markets and the dominant financial centre in the European time zone with unparalleled experience in the provision of international financial services and risk capital.

In the City of London Japanese financial institutions have increased their presence, extended the scope of their activities and established their position even more firmly in the financial community. In the City of London we now house all the biggest and broadest financial markets. The City of London enjoys a breadth of liquidity which no other European centre has, and this makes it easier to cope with huge surges of global activity. The fact is that London leads its nearest rivals in Europe by a substantial margin in every single sphere. And there is an important knock-on benefit for direct investment – industrial investment from overseas. American, Japanese and other investors are attracted to our shores because in London we have Europe's top capital markets and because they believe they can operate more profitably in *this* country.

We now house the greatest concentration of international financial experts in the world. 40 per cent of our work force in the City is employed by overseas firms and London as a whole is the business capital of Europe. Of the top 500 corporate headquarters in Europe, the UK houses 187, France 77, Germany 67, Italy 25, Netherlands 17. With London housing 40 per cent of the top 100 headquarters in the UK.

A year ago a leading Danish Diplomat said: 'there are three ways of doing things – the right way, the wrong way and the British way'. Our way is OPEN DOOR and a liberal pragmatic approach to international trade. The most important thing to remember about London is that it has centuries of tradition as an international centre

stretching back to Roman times. Over the centuries we have welcomed the Hansa, the Flemish, the Huguenots and many others. This tradition distinguishes UK from other centres. I have met and talked to over 150 overseas bankers in the City in the last few months and as they put it; 'In London you have this stability of tradition, and this tradition of stability to ensure that overseas participants have always found a warm welcome, and in most cases, prosperity.' These foreign firms like our open ways, our housing on a human scale, our night life, our theatres, our restaurants, our great celebrations, our traditions. People can come here with their families. We have Japanese schools, American schools, a capital city full of learning, culture, sport and history.

We differ from other European cities. Where else could you find foreign participants in our markets, our institutions? An American Banker is Deputy Chairman of our Stock Exchange, a German Banker is Deputy Chairman of the Confederation of British Industry, London Region. Overseas members are on the Boards of our financial futures exchange and our self regulatory organisations. This is all part of our open-access internationalist approach.

Most importantly, the City has now reached a critical mass in all phases of the financial market and the essential ancillary supporting services and professions, like commercial law, consultancy, accountancy and arbitration; truly a one stop shop for financial services. We owe a great deal to the commitment of the Bank of England to maintain a flexible and enabling market framework. And the Corporation of London, the Authority for the City, is dedicated to provide the optimum environment for the business community – an international community.

On my recent visit to Merseyside, I took with me the Japanese commercial counsellor from their Embassy,

and I was particularly interested in showing him the tremendous infrastructure investments in that area and the enhanced attraction to overseas investors. He told me that one of the most potent reasons Japanese companies have been happy to locate in UK is that London is the financial epicentre of Europe with the biggest capital markets, an entire critical mass of supplementary services in commercial law, accountancy and insurance.

Those Japanese companies that have invested in the UK will be well rewarded for their perception in their strategic plans for the European markets, financial commercial and industrial. This Japanese foreign investment has of course clearly contributed to British economic growth and the creation of new jobs. It has also helped the technological level of many British manufacturing industries. Over the past five years Anglo-Japanese financial relations have deepened and strengthened.

Similarly British firms, many with international experience in the Asia Pacific region will do well to recognise that partnership with Japanese companies can do much to strengthen their position in this most dynamic of world markets. Overall there is being forged a fine relationship between Britain and Japan in many financial, industrial and commercial fields, a special relationship indeed. Again I quote Ambassador Kitamura: 'Britain has no better friend than Japan in the East and Japan has no better friend than Britain in Europe'.

In summary the City of London is the most dynamic of markets, combining deep liquidity with great expertise and an unrivalled range of international innovative products. Business is booming and we are so appreciative of Japan's interest and her involvement. The real fact is that London is now increasingly seen outside Europe as the stepping stone into Europe.'

When I visited Tokyo, Osaka and Kyoto a few days later, one of my main tasks was indeed to thank my hosts for the Japanese commitment to the United Kingdom's economy and, not least, to the City of London.

Japanese investment in Britain by manufacturers, financial institutions, property companies and insurance companies was not always profitable and, as is described earlier, inflated prices were paid for real estate in many cases, not least in the City. However, the benefits to the UK extend well beyond those celebrated by economic statistics.

Industrial investment has played a most valuable role in rejuvenating ailing British industrial sectors, and has led to the transfer of much production 'know-how'. Japanese methods of production quality-control, inventory management and labour relations have resulted in real, albeit unquantifiable, knock-on benefits to British industry generally.

Lord Young of Graffham made the following comments, in a speech in 1994:

'Many Japanese ask why the US or UK Governments do so much to welcome Japanese investment, whilst apparently being unable to encourage their own companies to make similar quality investment in their own countries. This may be odd, and it was disputed for many years, but now I think it is accepted that the British Government policy on Japanese investment has been very good for the British economy. I go back to where I started, the consumer electronic sector: over the last twelve or fourteen years there has been a radical transformation. Our indigenous industry has, in effect, gone out of existence, but it has been replaced by the full panoply of Japanese consumer electronics concerns – Sony, Matsushita,

Toshiba, Hitachi, Sharp, JVC, Aiwa, Sanyo, Mitsubishi Electric, NEC with some of their component suppliers.

The trade balance has been changed with exports now exceeding imports. Television sets and electronic goods and the production of over 3 million sets which was once – I still have a copy of the report – considered impossible by the NEDDY Consumer Electronic Working Party. There are lessons in that. The Japanese are cautious when they go abroad, but once the ice is broken, they tend to hunt in packs. The presence in the UK of all the Japanese consumer electronic companies is a great asset, and augurs well for the future when the same Japanese companies use their UK bases for migrating up to industrial electronics and other IT products.'

In September 1994 a conference 'The Global Workplace' was held in Canterbury with the specific aim of stimulating discussions on the benefits which Japan had brought to this country. The Archbishop of York referred to aspects of the Japanese cultural framework underlying Japan's industrial strength; the sense of community within business enterprises, a sense of the common good and an educational system with a strong emphasis on the recognition of merit 'without the kind of envy and false egalitarianism which has been such a feature recently of British . . . education'. He added that the confrontational view of industrial relations is seen in Japan to be an absurdity, and he dwelt on the benefits flowing from the Japanese incorporation of many of their traditional cultural values into their business ethos.

Sir Leslie Fielding,[5] at the same conference, said:

'the Japanese economic and industrial presence in the UK is here to stay. Opposition from the trade unions

. . . is a thing of the past. Twenty billion pounds of cumulative Japanese investment in the UK – 40 per cent of Japan's entire investment in Europe as a whole, 206 Japanese manufacturing firms and 70,000 British jobs created by Japan – all that is worth having. So, too, is the closer relationship opening up before our eyes – to our astonishment, and sometimes to our discomfort – between British and Japanese managers and workers. Neither our trade unionists nor our bosses quite know how it works or why it should work, but it does, and the stimulus is healthy for everyone.'

Thus, it can be said that, whereas in the late 19th century, and in the early years of the 20th century Japan learned much from Britain, any debt of gratitude has been repaid by the Japanese contribution to the British economy generally, in the City of London and throughout the United Kingdom.

INVESTMENT BY JAPANESE LIFE INSURANCE COMPANIES

Japanese life insurance companies manage between 20 and 25 per cent of financial assets owned by Japanese individuals, and in the late 1980s, these firms promised their clients a higher yield on their life-insurance savings than on yen bonds. Economic growth in Japan, and the popularity of life policies as mediums for long-term investment led to a huge growth in investible assets at that time.

Accordingly their interest in foreign securities increased sharply over that period, and foreign holdings rose from 9 per cent to 15 per cent of their portfolios between 1985 and 1989. They were substantial investors in British securities, both government bonds and equities. They also channelled their investments in European equities, including 'country funds', through British fund-management

groups, since London was adjudged to be the best centre for the management of European equity portfolios.

It was natural for them, therefore, to diversify their investments into investment houses and fund-management groups, especially those to whom they gave a lot of business. As an example, Daichi Uno owned between 3 ½ per cent and 4 per cent of S.G. Warburg & Co, prior to the latter's purchase by Swiss Bank in 1995. Mitsui Life and Daido Life invested in M.I.M. Britannia, the City based fund-managers, and, in Edinburgh, Sumitomo Life bought a stake in Ivory & Sime.

They made aggressive, and largely ill-timed purchases in real estate markets in the United States, and then in London. Their London property investments (described in detail in the next few pages) totalled over £1.1 billion in the years 1988 to 1991, the prominent buyers being Asahi Life, Chiyoda Life, Dai-Ichi Life, Meiji Life, Nippon Life, Sumitomo Life and Yasuda Life.

JAPANESE PROPERTY INVESTMENT IN LONDON FROM 1985
[from papers kindly prepared by John Slade, partner, Richard Ellis & Co and David Glascock, partner, Weatherall Green & Smith]

As in America, the initial investment in British real estate by the Japanese was led by developers and real estate companies. These were followed by life insurance companies, and they arrived as committed buyers of the best properties, especially in the City of London. Quality-consciousness, rather than price-sensitivity, was a common feature of their approach and, while they sought the advice of London's leading firms of Chartered Surveyors, they were often prepared to pay top prices to obtain prime property in prestigious locations. In many cases, the Japanese had to pay such prices to tempt owners

to sell and were buying, as property professionals put it 'off the market'. The life insurance companies were required to seek the approval of the Japanese Ministry of Finance for such purchases; this was a lengthy process, requiring much patience on the vendors' part, and frequently the latter required a higher price to compensate for such delay.

The process began in 1985, with acquisitions by Mitsui Real Estate, Kumagai Gumi and Mitsubishi Real Estate in four deals totalling about £126 million. In 1986 five acquisitions by Japanese developers totalled £250 million, followed by a figure of £450 million in 1987 in eleven transactions. In 1988, the Japanese life insurance companies entered the market for pure investment purposes. Yasuda Mutual Life bought River Plate House, Finsbury Circus for £140 million from a joint venture development partnership of Taisei (a Japanese contractor) and Hammerson, and Dai-Ichi Life bought the Randsworth Centre in Wilson Street for a more modest £39 million. By the end of 1988, Japanese property investment in London totalled £1.43 billion.

These large commitments were partly a function of interest and exchange rates in Japan. A strong yen made UK real estate seem cheap, and, until the end of 1987, Japanese interest rates remained below 5 ½ per cent. There was plenty of money available for acquisition and development at very cheap rates.

The Japanese life insurance companies continued to buy aggressively. Nippon Life, Chiyoda Life, Dai-Ichi Life and Sumitomo Life were prominent in 1989, but the most notable purchase was Asahi Life's acquisition of Leadenhall Court for just under £120 million, on a long leasehold geared to 25 per cent of the rents received, off a rent of £60 per square foot and a yield of 4.75 per cent. The latter was a demonstration of Asahi Life's expectation of huge rental growth; today that building would let for no

more than £35 per square foot, and the yield would be over 6 per cent. Overall, in 1989 alone Japanese companies invested well over £1 billion in London property in over 20 acquisitions. The largest purchase of all was made in 1990, when Sumitomo Life bought 52.5 per cent of J.P. Morgan's building in EC4 for £220 million, a transaction structured on an increasing equity share rising from 15 per cent upwards over a period of years. Dai-Ichi Life also bought a stake in Minster Court, EC3, in a joint venture with Prudential Assurance and Meiji Life paid £150 million for 50 per cent of the Goldman Sachs building in Fleet Street. Nippon Life's £100 million acquisition of Clifford Chance's headquarters in Little Britain was a feature of the City's property market in 1991.

Demand was mainly centred on new, prime, fully let buildings with good tenants and a secure income in anticipation of good long-term growth, but by 1990 the flood-tide of property investment was receding. The dramatic growth in the Japanese economy until then had let to an excess of funds available for overseas purchases. A boom in the amount of life insurance and saving policies sold in Japan, low interest rates (rendering bank savings accounts relatively unattractive) and a strong stock market had all contributed. Between 1989 and early 1991 Japanese long-term prime rates were moving upwards. A 50 per cent rise in the yen, and a 50 per cent fall in prime central London rents which was to follow resulted in huge losses in yen terms: the downturn in the Japanese economy, the failure of loans repaid to Japan from UK property rentals to meet target returns, (taking the exchange rate into account) and the sharp fall in the Japanese stock market in 1990 combined to switch off the flow of such investment. New Japanese acquisitions for pure investment in London property virtually halted.

Some of the purchases were thwarted by events. When,

in 1990, Daiwa Securities Group invested £70 million in a property in Wood Street to house their European headquarters, planning permission had already been granted by the Corporation of London. However an immediate, and seemingly perverse spot listing by English Heritage aborted the new development and, by the time permission to develop was removed after strenuous efforts, the securities market had collapsed in Tokyo, and Daiwa decided to defer development until the financial environment had improved (development is now planned in 1996). 1995 has seen a little fresh movement in the market, as City rentals began to move up again in 1994. C. Itoh has now bought out Guardian Royal Exchange's share in the old Daily Express building in Fleet Street, jointly acquired in 1989, and Mitsubishi Real Estate has now bought out its partners in the long-delayed Paternoster Square development, although its future plans have yet to be declared.

Even though these many and substantial investments have not, as yet, performed as well as their purchasers and their consultant advisers would have wished, and current values remain substantially below book costs in most cases, the current trend seems to be one of consolidation of existing commitments, and this must be seen as a mark of confidence in the City's future prosperity.

Table 4.1: Japanese property purchases in London
(Reproduced, with amendments, by kind permission of Weatherall, Green & Smith)

DATE	PURCHASER	ADDRESS	PRICE £M	COMMENTS
1985	Mitsui Fudosan	St James Square	30	Retail redevelopment of the former Bourne & Hollingsworth site.
	Kumagai Gumi	The Plaza, Oxford St	15	Subsequently sold to Nomura real estate
	Kumagai Gumi	P.O. Site, No1 St. Martin's-le-Grand	45	for Nomura Securities London headquarters
	Mitsubishi Real Estate	Atlas House	36	
TOTAL			126.0	
1986	Kumagai Gumi	41/55 Bishopsgate	90	A joint purchase with a Japanese bank. Affected by Bishopsgate bomb.
	Shimizu	6/8 Bond Street	7	
	Taisei	Finsbury Circus	25	Subsequently sold to Yasuda Life in 1988 for £140 million.
	Kajima	101 Piccadilly	10	
	Nomura	P.O. Site	125	Former development by Kumagai Gumi
TOTAL			257.0	
1987	Kumagai Gumi	Moss Bros	23	
	Ohbayashi	Bracken House	143	Spot listed the day after acquisition. Now IBJ's headquarters.
	Quick	65 Cliffon Street	12.2	
	Kumagai Gumi	Malvern House	50	Redeveloped and subsequently sold in 1994. HSBC headquarters in London.
	Takenaka	24 Lombard Street	70	
	C. Itoh	Austin Friars	15	Never fully occupied.
	C. Itoh	25 Lombard Street	27.5	
	Kumagai Gumi	Whitefriars	72	Freshfield headquarters
	Kumagai Gumi	20 St James's Square	30.5	Sold to GAN/UAP in 1994. Let to Grand Metropolitan.
TOTAL			443.2	

Table 4.1 continued

DATE	PURCHASER	ADDRESS	PRICE £M	COMMENTS
1988	Kumagai Gumi	Stanhope Gate	22	
	C. Itoh	Aitken House	21.5	
	TDK	Redhill	6.5	
	Mitsubishi Trust	24 Lombard Street	80.0	
	Mitsubishi Corp	Bow Bells	70	
	Kajima	Hanway House	20.0	
	Yasuda Life	River Plate House, Finsbury Circus	140.0	
	Abe International	222 Marylebone Road	38.5	Defaulted on payments to construction company, Hazama Corporation in 1993. Currently owned by Hazama and available for purchase. Now operates as Regent Hotel.
	Seibu Saison	Various	100	
	Dai Ichi Life	Wilson Street	39	
	Shimizu	Fenchurch Street	65	
	C. Itoh	Tenterten Street	5	Sold 1994 (only sale by a major life insurance company in London).
TOTAL			607.5	
1989	Nissho Iwai	Various	15	
	Matsushita	State House	45	
	C. Itoh	Daily Express	45	Joint venture purchase with GRE. High price paid for acquisition. Property has not yet been developed, and C. Itoh has now bought GRE's share.
	Asahi Life	Leadenhall Street	118.75	Long leasehold acquisition geared to 25% of the rent received off £60 per sq ft rent and 4.75% yield.
	various	County Hall	20	Purchase not pursued, deposit lost.
	Sumitomo Life	Angel Court	80.5	
	Sumitomo Life	68 Lombard Street	55	
	Shirayama Corp	County Hall	60	
	Nippon Life	King William Street	40	

Table 4.1 continued

DATE	PURCHASER	ADDRESS	PRICE £ M	COMMENTS
	Mitsui Fudosan	Old Bailey	125	Bought on a 50/50 venture with Mitsui Corporation who occupy the top two floors.
	Kajima	Euston Square	57.5	
	Shimizu	56 Piccadilly	28	
	Shimizu	Caslon House	15	
	EIE	Britannic House West	198	Sold 1995 for around £50 million to Development Securities, financed by Commerzbank, to be occupied by Linklaters & Paine.
	Kumagai Gumi	11 Waterloo Place	20	
	Kato Kagaku	Bush House	138	Purchased for depreciation purposes over 12 years.
	Kumagai Gumi	38 Bishopsgate	145	Occupied by LTCB as London headquarters.
	Mitsui Construction Co	83/89 Grays Inn Road	10	
	Kowa	Basinghall Street	30	25% share in Pru/Waites joint venture of City Place House. Subsequently let to Sanwa Bank.
	Kumagai Gumi	30-34 Kingsway	25	
	Mitsui Construction	St Mary Abbots Hospital	23	Sold for residential development by Taylor Woodrow.
	Chiyoda Life	120 Holborn	30	BT Headquarters Holborn
TOTAL			1325.75	
1990	Mitsubishi Real Estate	Paternoster Square	15	Subsequently purchased for £100 million with debt finance in excess of £250 million. Park Tower realty and Greycoat's interests bought July 1995 for undisclosed sum.
	Daiwa Securities Group	Wood Street	70	A former telephone exchange spot listed after purchase. Spot listing removed on appeal. It was to be Daiwa Securities' European headquarters but site has yet to be developed.
	Tokio M & F	150 Leadenhall	60	
	Sumitomo Life	52.5% JP Morgan Building	220	Increasing equity share in acquisition.
	Sumitomo Corp.	50% Vintry House	40	Joint venture with Waites.
	Meiji Life	50% Goldman Sachs Building	150	A limited partnership agreement.
	Dai-Ichi Life	Minster Court	100	Joint venture with the Prudential.

Table 4.1 continued

DATE	PURCHASER	ADDRESS	PRICE £M	COMMENTS
	Asahi Urban Development	Mutual House, W1	20	
	Orix	Romney House, SW1	49	Bought for depreciation purposes. 60 £1 million shares sold in Japan for tax loss purposes.
	Chiyoda Life	120 Holborn	30	A further 25% stake in BT headquarters building resulting in 50/50 joint venture with Norwich Union.
TOTAL			754	
1991	Nippon Life	50% Little Britain	100	50% purchase of Wimpey's development. Let to Clifford Chance. Wimpey share sold in 1994 to the Prudential.
	Asahi Life	Broadgate (part)	20	£20 million stake in Prudential global fund (total acquisition price £100 million).
TOTAL			120	
GRAND TOTAL			£3.63 BN	

CHAPTER 5

The Early 1990s – Regrouping And Retrenchment

Regrouping And Retrenchment • Japanese Perceptions Of London In Europe – 1991 • Polarisation Towards London 1992-1994 • Security Aspects 1992-1994 • Lessons Of 1995 – And The European Context

REGROUPING AND RETRENCHMENT

By 1990, there were 107 Japanese financial institutions in the City of London. They were grouped as follows:[1]

Branches and representative offices of banks	44
Securities subsidiaries of banks	23
Subsidiaries and representative offices of securities houses	34
Banking subsidiaries of securities houses	4
Consortium banks	2

Not included in the above are the Bank of Japan's London office, insurance, leasing and finance companies.

At that time, according to the Bank of England, Japanese bank branches in London had assets standing at £282 billion – roughly one quarter of that of all banks in the U.K. These institutions continued to diversify their operations and were moving into new areas e.g. loans and bonds. The ratio of sterling assets of Japanese banks in the UK had reached almost 12 per cent. Nearly 80 per cent of all personnel on the books of Japanese banks' London branches were non-Japanese. There was indeed a movement towards what was described as 'local market orientation'. Project financing, in particular was increasing; Japanese banks were to finance about 20 per cent of the required funds for the Euro-tunnel Project.

By 1991, however, there began to be signs that the flood tide of the Japanese financial expansion abroad was starting to ebb. After ten years of rapid expansion, Dr Andreas Prindl of Nomura Banking in a speech in Cambridge in that year pointed out that the Japanese banks had begun to retrench quite rapidly, that the percentage of Japanese bank assets in the UK, compared to the total assets of all banks had fallen from just over 30 per cent in 1989 to 20 per cent in January 1991, that the Japanese share in international lending was also falling, that there were reports of Japanese banks not taking up their expected tranches of syndicated loans, and that some Japanese lines of credit to European corporate borrowers had been cancelled. The reasons Dr Prindl gave for these phenomena were not that the Japanese trade surplus had fallen somewhat or that huge losses on LDC debt had hurt Japanese banks (which they had). Rather his explanation was that

1. The Tokyo stock market crash (by 45 per cent) in 1990 had weakened their ability to meet the BIS Capital adequacy requirements by 1991 – hence the attempt to rein back in asset growth.

2. The Bank of Japan's credit squeeze, since mid-1989 had affected the banks' direct credit expansion ceilings.
3. There were fears of a collapse in the inflated real estate market, leading to a possible deterioration in the banks' assets in the shape of their substantial loans to property developers.
4. There had been an acceleration of corporate bankruptcies in Japan, weakening corporate loan books.
5. There was a fall in the volume of new international lending deals, with poor margins.
6. A decline had taken place in the appetite of Japanese investors for foreign securities as a result of tight money in Japan.

Prindl pointed to other, more long-term considerations. Japanese banks, having established their external network would now concentrate more on domestic matters because of expected future liberalisation of the Tokyo markets, there was more competition in Tokyo from foreign brokers and there had been poor experience by foreign banks which had bought British financial houses after Big Bang (including Bank of Yokohama's seemingly ill-timed purchase of Guinness Mahon in London in 1989). He concluded that, outside Japan, the Japanese faced the same high costs as western banks and the same overcapacity in banking, and that there was no hidden Japanese advantage in cost, customer base, or innovation which would give them a competitive advantage. In particular, the great advantage which they had enjoyed as intermediaries in 'the wave of Japanese external flows' was declining, as that wave subsided. Bill Emmott, in an article 'The Ebb Tide' in the Supplement to the Economist in April 1991 clearly held a similar view – that the tide had turned.

In March 1992 in a speech in Edinburgh at a conference

organised by the Anglo-Japanese Economic Institute, one of the speakers, Mr Seiichi Masuyama[2] spoke as follows, 'The general plight of the Japanese financial industry at home and in Europe is bound to have an impact on both Japanese foreign direct investment and the operations of Japanese industrial corporations in Europe'. He foresaw a slowing-down in the growth of FDI rather than a cessation, and a change in the structure of these investments to increased size for their existing presence in Europe rather than the advent of new investors. He predicted that the impact of this, and the need for more integration, on Japanese financial houses would lead the latter to scale down some of their operations, restricting their European offices and, significantly to 'the pooling of resources in a single centre in Europe, from which necessary expertise will be provided to support all the European offices. This centre will probably be located in the largest financial centre in Europe . . . as long as the UK participates in European financial and monetary integration . . . this place will be London, although European diversity will probably require several sub-centres'.

One is led to the conclusion that the process of regrouping will continue for the foreseeable future, with London remaining the hub.

JAPANESE PERCEPTIONS OF LONDON IN EUROPE – 1991

Perceptions are, of course, all-important in any decision-making process; once established, they do not change quickly. Japanese perceptions of the trends in global financial markets, of the European financial and banking scene, and of London vis-à-vis other European centres have been crucial for their location decisions. A helpful test of these perceptions was made in 1991. In that year, The Financial Markets Group of the London School of

Economics organised a joint conference on European Financial Markets. The peculiar value of this conference was that each paper presented was followed by a response from a Japanese expert. These responses provided an invaluable summary of contemporary Japanese perceptions. In 1991, the United Kingdom was still a participant in the Exchange Rate Mechanism, and pious hopes were being expressed about reduction in exchange rate uncertainty (such uncertainty has been, and remains, highly profitable for banks).

The 1980s had indeed seen a decline in the economic supremacy of the United States and the emergence of Japan as a global economic and financial power. In the period 1985-9, a burgeoning current account surplus had led to an accumulation of $350 billion, making Japan the world's largest exporter of capital – and the world's largest creditor. By 1989, long-term capital exports totalled $192 billion and the net external creditor position reached $292 billion by the end of that year. The Japanese private sector now owned some $550 billion of external financial assets. In 1990, the boom was ending. The stock market started its long correction, domestic liquidity creation slowed down, and capital exports halved from the previous year. This ushering-in of a period of consolidation still left Japan as a major holder of global financial assets, and as a major supplier of capital globally. Nevertheless, it was a turning-point, and provided an interesting background for Japanese commentators to propound on their views of the European financial scene.

The conference was held in coordination with the Institute of Fiscal and Monetary Policy of the Ministry of Finance (President, Mr Yuichiro Nagatomi) and the Foundation for Advanced Information and Research (President, Mr Sadaaki B. Hirasawa). The Co-Directors of the Financial Markets Group were Mr Charles Goodhart

and Professor Mervyn King of the London School of Economics. The highlights were as follows:

Mr Toyoo Gyohten of Princeton University expressed the view that Europe was destined to remain a continent of nations. He was concerned that aspirations for a single Europe, not shared by all EU members, might lead to a 'discriminatory block of certain countries'. (It has been observed that such fears are still alive today in Japanese thinking).

Mr Isao Kubota of the Overseas Economic Cooperation Fund was doubtful as to whether achieving European Monetary Union had any meaningful implications for Japan, and, reflected that convergence of fiscal policies within Europe was an essential pre-requisite for monetary union, even if monetary policy was successfully coordinated. He very much doubted whether individual countries would be prepared to surrender their authority over taxation policy – this was easily the most politically sensitive issue in many countries. He rightly pointed out that there would have to be a consensus across the EU as to an acceptable trade-off between growth and inflation.

Mr Tomonori Naruse of the Bank of Tokyo made the point, still very valid today, that Japanese banks were concerned over being able to satisfy the Capital Ratio Adequacy Requirements. He estimated that Japanese banks' share of European banking was about 10 per cent – up from 8 per cent in 1985, and stated that the establishment of Western European networks by the major Japanese banks was about complete. Apart from some private banking services in Switzerland, the business of Japanese banks in Europe was overwhelmingly wholesale, including Euromarket transactions – and was likely to remain so. Activity in the major financial centres, facilitating direct investment in the E.C. by Japanese non-financial companies was being joined by support

for those companies wishing to expand in Asia and in the provision of special financial packages such as the use of swaps and options techniques.

Mr Naruse foresaw a new trend for Japanese insurance companies to embark on banking business in Europe as they were already doing in the US (e.g. Nippon Life's stake in Shearson Lehman), by acquiring equity in European banks and learning their businesses. (He could have added that such investment also had the aim of learning expertise in portfolio management, and the training of Japanese personnel for that purpose.) On the subject of the relative attractions of London, Frankfurt and Paris as international financial centres, Mr Naruse offered the view that London would remain the principal international centre, allowing that its relative status might decline slightly – and that Paris and Frankfurt would develop as satellite markets, complementing London. He referred, in particular, to the hugely superior volume of foreign exchange transactions in London especially cross-currency. Further, he described London's leadership in developing innovative financial products, in information flow and in highly supportive professional services such as law, accountancy, and computer software. He stressed the supportive role of the Bank of England in London's remaining 'the one truly international financial centre, and not just the European financial centre'.

POLARISATION TOWARDS LONDON 1992-4

In the late summer of 1992, a wave of activity in foreign exchange markets worldwide made it clear that London was the leading centre for such activity, and best able to absorb the substantial volumes which were generated by the currency crisis in Europe. The Bank for International Settlement's statistics released that year showed that 27 per

cent of global foreign exchange turnover was traded in London – more than the totals for New York and Tokyo combined. By 1993, a measure of the large percentage of Japanese equities traded away from Tokyo was revealed when in that year London accounted for nearly one third of all share trading in Matsushita, the leading electronics manufacturer. In 1994, Japanese equities accounted for 23 per cent of all equity turnover on the London Stock Exchange, on which 2,983 Japanese stocks were traded.[3] In the early spring of 1994, there was a huge flurry of activity in international bond markets consequent upon the start of the rise in US interest rates which shocked the market in February of that year. Bond derivatives were especially active, and, again, London proved to be by far the most liquid and competitive market for such transactions in Europe.

In 1993, the concession which allowed Japanese banks to engage in stockbroking led to the opening, in 1994, of securities subsidiaries by six large Japanese banks as a result of this measure of deregulation. The latter, combined with the need for those banks to achieve economies hastened the process of polarisation of those banks' European activities in favour of London as the best base for securities business. A process of 'streamlining' of those banks' European branches was set in motion (the weakness of Eurobond and equity markets in Europe added to the pressure on brokers' profits, and they later announced significant cuts in their overall European staffs).

The Industrial Bank of Japan (IBJ) was one of the banks allowed to set up securities arms. Its City of London-based securities subsidiary, IBJ International had been in London for eighteen years and this experience gave it a strong advantage in developing domestic operations. However IBJ was also keen to expand further in London, since it believed that its domestic securities business would

lead to further European business opportunities. While the securities houses were busy cutting overheads, IBJ, therefore was continuing to expand in the City and in 1993 announced plans to increase its London staff from 300 to 500 over the ensuing four years by increasing sales, trading, and support staff. Significantly this announcement came only one month after the Bishopsgate bombing episode. Mr Tobe, IBJ's managing director dismissed suggestions that terrorist attacks would lead to an exodus of Japanese financial institutions saying 'London is too important, especially as a learning ground'.

There was undoubtedly increased pressure on banks to concentrate their activities as principals. This had much to do with access to a pool of highly skilled labour, and to a large critical mass of supporting services, but also to the perceived importance of interaction with other firms and synergies between different activities within each firm. In particular, the costs of risk management across different product lines were increasingly recognised as being much lower when such management was conducted from one centre. Synergies between different activities are also clear in that financial houses can lay off risk and have lower spreads when they are active in the markets of the derivatives of an underlying asset. Currency derivatives such as forward markets, swaps and currency options have an important part to play in this context, as have interest-rate derivatives for firms active in underwriting fixed-rate bonds, and in the provision of syndicated loans. Again, London's clear leadership, globally, in foreign exchange turnover and in international securities underwriting counted heavily in its favour. Also, the rapid development in financial innovation has been partly the cause, and partly the effect of the polarisation of financial activity.

In assessing the future for international financial activity,

the concentration in London has been, therefore, something of a virtuous circle – and this makes it much harder for any other European centre to exert a competitive challenge.

Significantly, in April 1994 Nomura announced that London, which was already the administrative centre for its European branches, was also to become its European operating headquarters and that, in future, its fifteen offices in Europe were to report directly to London and no longer to Tokyo.

In March 1994, the position of the Japanese brokers in London was summarised in Miss Fukuda's lecture, referred to earlier, as follows:

> 'Broadly the business of Japanese securities companies can be described as in three parts – each of them of equal importance in revenue terms. They are stockbroking in equities – Japanese and non-Japanese; broking and trading in bonds – Japanese and non-Japanese – of both domestic and Euro variety; and underwriting. Their clients are large institutions in Britain and the Continent of Europe, the latter of which are serviced also from the offices and branches on the Continent. Typically, the Big Four have subsidiaries or branches in Paris, Frankfurt, Amsterdam, Zurich, Geneva, Lugano, Milan, Madrid, Bahrain, – Nomura is in Brussels also, and Nikko is in Luxembourg and there are some differences in additional office locations – but by and large the business of the Big Four is identical with each other, and London is their headquarters. I think it is fair to say that for them all London is the most important centre for their international operations.'

The full range of activities engaged in by Japanese securities houses in London in 1994 was described in these words:

'in the equity area, they all have broking and market-making facilities in Japanese equities, and they all to a greater or lesser extent deal in non-Japanese equities of the UK, continental European countries, and the Asian emerging markets. Nomura makes a market in UK equities, which the other three do not. In the bond market, all the Big Four are major players in the bonds of every denomination of major currencies. In both equities and bonds they all deal in all the associated derivative markets and they are all members of LIFFE.

In capital markets activity they are important players as underwriters in the new issue business. Sovereign debt and quasi-sovereign debt are the principal products of this market and because they have a strong capital base they can underwrite billions of dollars of new issues at any one time and because they have the broking and dealing capability mentioned earlier they can pass on these primary market securities to the secondary market. Recently, as the strong momentum for privatisation has gathered pace, offers of equities to international investors through international syndicates, both underwritten and not, have come into this primary market activity of the Japanese brokers. In addition the Japanese houses have with modest success entered into what may be described as fee business in corporate finance advisory work. Using their wide international corporate client base, they have been modestly successful in M & A and advisory services to governments on privatisation. These are traditionally the business of merchant banks in the UK and investment banks in the US. But these need not fear competition from Japan because they are far more experienced and far more gifted in their expertise.

The Japanese firms in the City today are trying to grasp the nettle of this change, to survive as leading players in the international securities markets. They

decided against buying into British firms at the time of Big Bang even though they were conscious of the need to widen their operational base. This consciousness has been growing ever more strongly since the collapse of the Japanese stock market. Diversifying sources of revenue is of paramount importance and they have come to recognise that they have to recruit local experts rather than relying on bringing Japanese managers from Tokyo. Thus the word 'localisation' is the current motto for them.'

There has, in the period 1994-5 been some retrenchment of these activities in London, especially in the market making activities which Miss Fukuda described. Nevertheless, the total commitment remains very substantial. By 1994, there were twenty nine Japanese brokers in London and twenty three securities subsidiaries of Japanese banks. By the spring of that year Nomura employed a total of 550 people and Nikko 350, of whom 80 per cent were British. This high proportion of local employees is now common to all the main Japanese houses.

SECURITY ASPECTS 1992-4

There have been two major terrorist incidents in recent years in the City of London. In April 1992, the Provisional IRA detonated a lorry-borne bomb outside the Baltic Exchange in St Mary Axe in the City. Three people were killed and 91 injured. The Sanwa Bank, located in the Commercial Union building which was hit, was obliged to move to another city location. In April 1993, a second lorry bomb exploded in Bishopsgate, killing one person, but causing more extensive damage. Two Japanese-owned properties in Bishopsgate were affected, both partly owned by Kumagai Gumi, namely 41-55

Bishopsgate, and 38 Bishopsgate. The Long Term Credit Bank of Japan, who owned 50 per cent of 55 Bishopsgate which housed their London Branch was forced, as a result of the extensive damage, to move to a temporary office for nearly two years.

These outrages were designed deliberately to inflict the maximum economic damage to the United Kingdom by striking at the heart of its financial centre, the cradle of the vast bulk of its foreign exchange earnings from financial services. The very compactness of the City of London, the Square Mile, which gives it such an edge over other money centres now served to accentuate its vulnerability. To help make the point, the IRA then wrote a round-robin letter to many of the leading foreign houses in the City, including the Japanese but excluding, for obvious reasons, American firms. This letter's concluding paragraph stated 'We do not seek to target those with whom we have no quarrel. But the reality is that simply by virtue of their location many businesses will suffer the effect of our operations. In the context of present political realities, further attacks on the City of London and elsewhere are inevitable. This we feel we are bound to convey to you directly, to allow you to make fully informed decisions'. It was signed 'on behalf of the IRA leadership, P.O. Neill, Irish Republican Publicity Bureau'.

On April 26, the Japanese Chamber of Commerce and Industry wrote to the then Home Secretary Mr Kenneth Clarke. In that letter, Mr T. Kaku, the President of the Chamber wrote:-

'I am writing now to make clear that the Japanese business community in the UK, and in the City in particular, is gravely concerned about the serious daily danger to life, assets and business posed by the threat of

IRA terrorism, which does not seem to be under control by the Government.

We appreciate that you are taking every security measure possible to prevent such devastation to innocent citizens and businesses. However, if you are unable to introduce more stringent and vigilant measures to curtail the IRA's destruction, there is a real possibility that Japanese companies will have to look for a safer alternative, such as another financial centre elsewhere in the EC.

I am sure that you are aware of the contribution made by Japanese direct investment in the UK over the past two decades, which has represented more than 40 per cent of Japanese investment in Europe. It would be a great pity, therefore, if Japanese business were forced to move out of the UK by a failure to produce a policy which effective in preventing terrorist crime on the present scale.'

The Home Secretary in his letter of May 20 replied 'Last week the Prime Minister and I met the Lord Mayor of London to discuss security arrangements in the City. The Government fully supports the action which has already been put in hand to improve the existing security measures in order to avoid further terrorist outrages in the City'. Several of the Japanese firms stated at the time that they would reconsider their City location in the event of any further such attacks. Among the foreign banks in the city, the Japanese were understandably sensitive to the terrorist threat unused as they were, at the time, to the effect of urban terrorism on a densely packed commercial community. The considerations of these Japanese employers were not merely related to physical danger and the safety of their employees. Disruption of business, stress, and the added costs of insurance were also factors.

The second attack on the City prompted the Corporation of London, the City's dedicated local authority to take urgent and dramatic action. Because the Corporation is the police authority for the City of London Police, such measures could be taken – especially as regards traffic restraint and vehicle checks under the City's local powers. Because of the urgency of the situation, action had to be taken with only brief advance warning to neighbouring local authorities, and after informing the Home Office.[4] Vehicle entry to the City was on July 7 1993 restricted to eight entry points only (reduced to four at weekends), and police officers were posted to check drivers and vehicles. These entry points were all monitored on screen at a central location, and in addition mobile armed police groups made spot checks. A network of additional monitored kerbside cameras was put into effect. In addition, the Corporation's own contingency planning procedures, set up after the bombing of the previous year, went into action. The second bomb exploded on a Friday evening, and over the ensuing weekend all the affected businesses in Bishopsgate were contacted by Corporation Staff and offered alternative accommodation on the following Monday. Their employees were able to call or visit the Guildhall direct to receive information regarding these alternative locations.

Over the succeeding months the major Japanese financial houses were all contacted and offered security briefings by the City Engineer, who with a team of security experts made visits accordingly to give advice on security procedures. There were, at the time, many who expressed some resentment at these traffic restrictions, and the overt police presence at fixed points and the armed patrols, but it soon became evident that this activity provided valued reassurance to City business people, and not least, the Japanese community in the City. Other benefits, too,

became increasingly manifest. There was a decline in overall traffic flows, in vehicle exhaust pollution, and in non-financial crime.

In November 1993, as Lord Mayor, I entertained together with my Lady Mayoress the leaders of the Japanese financial houses to a series of private lunches at the Mansion House. This enabled me to explain to these employers the full range of the Corporation's actions designed to raise the deterrence level against future terrorist attacks, to promote the availability of the Corporation's security team visits, and to ask my guests to give their personal reactions. At these meetings, the Chairman of the Policy and Resources Committee, Michael Cassidy, and the Commissioner of the City of London Police, Owen Kelly, were able to brief the guests in more detail. My guests were unanimous in their approval of the measures taken and many expressed their keen appreciation of the Corporation's programme of measures, and of the reassurance offered. These Japanese bankers and brokers were of course, fully aware that other financial centres around the world too had their security problems. Since 1980, Paris had suffered as much as London, and in 1993 the World Trade Centre in New York had been bombed. In December 1993 I was able to brief, privately, Mr Masuyaki Matsushima the chief representative in Europe of the Bank of Japan of all that the Corporation had done, and what it still planned to do.

My official visit to Tokyo in March 1994 provided a timely opportunity to report personally to the leaders of the financial houses in Tokyo about the range of measures taken to deter any further lorry-borne attacks, at several one-on-one meetings at their headquarters. Furthermore, an invitation from the President of the Tokyo Stock Exchange[5] to address about one hundred senior members was helpful in that the security situation could be explained

in positive terms. Again, all expressed satisfaction at the measures taken in the City. It was also a good opportunity to remind the audience of London's competitive position globally, in financial markets, and its dominance in virtually every facet of international financial activity.

A useful by-product of my visit to Tokyo, and later to Osaka and Kyoto was the information gleaned, especially at individual meetings – specifically to the effect that many banks were realigning their European branch systems by reducing their presence in continental Europe, and building further their presence in the City of London, especially in trading and securities activities. Above all, the visit made it possible for the Lord Mayor of London to pay his respects, on behalf of the City, to the political and business leaders of the day, including the then Prime Minister, Mr Morihiro Hosokawa, and Mr Hiraiwa, the President of the Keidanren. It was a useful health-check, and a reminder to all concerned that the Corporation of London's biggest priority was the creation and enhancement of the optimum secure business environment within the Square Mile of the City of London.

LESSONS OF 1995 – AND THE EUROPEAN CONTEXT

1995 will, no doubt, be regarded as a seminal year in the annals of the Japanese financial community and any account of its international aspects. The current 'depression' in the Japanese economy has been compared to the 'Showa Depression' of the late 1920s and early 1930s in that both are marked by allegedly near-crisis conditions in the banking and property sectors. Similarly, also, the problems are not helped by an unstable domestic political climate or by disagreements with important trading partners, such as the United States. Then, as now, the yen has been particularly strong, and there has been a preceding 'bubble'

in equity and real estate values, followed by a collapse. A whiff of deflation is again in the air, and concern is being expressed about the stability of the banking system.

The similarities extend to a developing trend of consolidation within the banking sector, with the Ministry of Finance and the Bank of Japan encouraging the emergence of stronger entities. The announcement, in March 1995, of the planned merger between the Mitsubishi Bank and the Bank of Tokyo, Japan's sixth and tenth largest banks respectively, to create the world's largest as measured by assets, reflected the changing attitude. It was, however, somewhat ironic that a Japanese central bank official greeted the merger as 'speeding up the reduction of bad debts which constitute a serious burden to Japanese banking', since both banks have, by Japanese standards, strong balance sheets and conservative styles of management and lending policy. While it is true to say that the stronger the financial position of a bank, the faster bad debts can be recognised in the accounts and written down, that merger was seen in London more as consolidating a resilient competitor in an increasingly competitive market place. A Eurobond syndicate manager in London was quoted as saying 'They are one of those . . . that is going to be around in ten years' time. They are always going to be there. They are not going to go away'. Strong capitalisation is also a feature of the leading Japanese securities houses, and it could be said that much the same comment could apply to them too.

There is now a general move, clearly encouraged by the Bank of Japan and the Ministry of Finance, to recognise and to write off or write down problem loans. Clearly, the stronger the financial position and operating profits of a bank, the more rapidly the non-performing element of a loan portfolio can be treated in a conservative manner. This trend is new, since, in the past, the Japanese banks

have not estimated total values for 'restructured' loans. It is fortuitous that low interest rates and high bond trading profits are facilitating faster write-offs. The eleven Japanese 'City Banks' have combined loan loss reserves equal to only 26 per cent of all problem loans, and some of them are clearly not in a strong enough position to recognise these in the near future. The situation will be exacerbated by the imminent liquidation of Japan's seven bankrupt housing loan companies which allegedly owe over Y 7,000 billion to the leading banks, and the contrasts between weaker and stronger banks will therefore become even more obvious. There are clearly more mergers in prospect. The Daiwa Bank's embarrassment in the late summer and early autumn of 1995 in the shape of accumulated and unreported losses in the US Government bonds in New York has led on to rumours of yet another major merger – with the Sumitomo Bank. The withdrawal of the Daiwa Bank's licence to operate in the United States, and the downsizing of its overseas operations by half, makes a merger with a stronger entity very likely.

The Japanese banks now form the largest single foreign grouping in London, in terms of banking, assets, and liabilities. In spite of recessionary and other strains, no Japanese bank has withdrawn from London and, since 1989, the Japanese banks' share in London's total banking assets has declined only modestly.[6] The downturn in the profits of Japanese financial houses generally has impacted major brokers such as Nomura who, in 1995 sharply reduced some of their City of London-based departments, their emerging markets group and their gilt-edged team being examples. These teams had, in fact, only recently been expanded in 1993 and 1994, and the cut-backs were no reflection of London's relative position; they were across the European board.

On September 30 1995, the *Economist* carried an article

stating that the Japanese banks were again building up their securities subsidiaries, especially in London. Mitsubishi Finance International, DKB International and Sumitomo Finance International were all reported as wishing to add substantially to their London staff, all by at least 50 per cent. This is a continuing reflection of deregulation in Japan of banks' securities activities, and especially the granting of licences, in November 1994, to six large banks, bringing the total number engaged in securities business to eighteen.

The continuing, and in some cases growing commitment to London, especially for securities business, reflects the repeatedly stated view by Japanese financial houses of all kinds that the City of London can accommodate the skilled staff and the sophisticated, liquid markets which they need, to operate on any real scale. The signs of London's growing stature as the financial base of choice within Europe have been dramatically highlighted in the past eighteen months with both the Deutsche Bank and Swiss Bank, two of the largest in Europe, declaring their intention to make London their headquarters for global business – leaving their home bases to handle their domestic business. These developments by their very size were major demonstrations of what has been a general trend adopted by other leading European banks, large and small – especially from Germany, Switzerland, Austria and Italy. It has all underlined London's position as Europe's city of markets and committed financial capital. The ING Group from the Netherlands and the Dresdner Bank, by making high profile acquisitions of British merchant banks, have added to the critical mass of commitment.

The announcement, in September 1995, of the preliminary figures from the Bank for International Settlements of world foreign exchange turnover revealed that, over the three years April 1992-April 1995, London's share of

world FOREX turnover had risen even further from its former 27 per cent to 30 per cent, and now equalled the combined totals of New York, Tokyo and Paris. As if to emphasise further London's appeal, the Healey & Baker annual survey of directors from fifty leading European companies, released in October 1995, revealed that London was again voted to be Europe's best city for business for the fifth successive year. Its lead over its nearest contender, Frankfurt, was shown to have increased further over the previous year.

The internal debate in the United Kingdom over Britain's future involvement in Europe is obviously a matter of concern to those Japanese whose investment here has been predicated upon Britain's membership of the European Union and the single financial market. British advocates of a single European currency may, however, be incorrect in assuming that, if sterling remained aloof, direct investment in Britain would be affected, or, worse still, that existing investors would leave. Such forebodings were sharply challenged in March 1995 by Miss Haruko Fukuda, Deputy Chairman of Nikko (Europe) and a leading spokesman for the Japanese financial community in London. At the 'Whither Britain' Conference that month, and in a parallel article in the *Daily Mail* she made the point that, far from being a deterrent to Japanese investment in Britain, British non-involvement in a single European currency was actually preferable for Japanese investors. Their interests, she pointed out, were best served by the benefits of a competitive exchange rate, and were, in that respect, identical to those of British exporters. In listing the factors attracting the Japanese she also added 'the continued pre-eminence of the City of London as a financial centre'.

None of the Japanese financial institutions in London questioned by the author in 1995 expressed concern about the principle or timing of Britain joining a single currency.

Indeed, the main concerns expressed were on matters to do with continued physical security, transport infrastructure, and the multiplicity of regulators. There was also an expressed wish that the 'onerous' work permit rules governing the employment of non-European nationals be eased, and a lurking fear of a more penal tax system.

In varying degrees, these institutions confirmed to the author their continuing confidence in their London base as their main European centre. The main reasons cited for such confidence were the efficient financial and legal structure, the regulatory framework, political stability, and the high-quality labour force, in each case the most attractive in Europe. The City of London's strong traditions and unrivalled facilities within Europe were quoted as the main reasons for its being the nerve centre for their European operations. Efficiency, expertise and tradition remain the main reasons why so many of them continue to concentrate their European functions in London even further.

CHAPTER 6

Spread of Involvement – The Good Citizens

Japanese Participation In The City's Institutions • Supporting Services – Insurance, Accountancy And Shipping • The Social Context – Charity, Foundations And Education • 'Two Strong Men'

JAPANESE PARTICIPATION

Japanese Chamber of Commerce and Industry in the United Kingdom

The JCCI was first established in July 1959, as the 'Japanese Chamber of Commerce in London', in the heart of the City. Its membership was then a mere thirty four companies, mainly financial, trading and shipping. As, over the next decade or so, Japanese direct investment expanded in the provinces the name was changed (in 1974) to reflect the wider geographic spread, but the Chamber's roots in the City remained strong. By March 1965 there were 414 member companies of which 184 were located in the City. Of the latter, many are trading houses, and

have contributed actively as members of the 'Task Force' supporting the 'Action Japan' campaign of the Department of Trade and Industry to increase British exports to Japan.

British Bankers Association

Representation by foreign banks on the General Council of the Association was introduced by BBA when its rules were amended in June 1986. Prior to that time, the Council was composed only of representatives of the British-based banks and, for historical reasons, the British Overseas and Commonwealth Banks Association (BOCBA) although foreign bank representatives had for some years been co-opted onto BBA's Executive Committee. However, it was felt that the importance of the foreign banks in the City, their impact in terms of market share and the increasing role and contribution they were making to BBA and its work, merited greater recognition and involvement in the BBA's principal policy-making body. Consequently, the Japanese banks, along with the American and Foreign Bankers' associations, were invited to nominate representatives to take their places on the Council.

Following discussions between Sir Jeremy Morse, BBA President at the time, and Mr Tatsuya Tamura, the Bank of Japan's Chief Representative in London, the Japanese banks nominated Mr Kunihiko Takai, Resident Managing Director for Europe and General Manager, London Office of the Bank of Tokyo, to serve as their first representative on the Council. Mr Takai attended the meeting of the Council on November 12 1986 where he received a warm welcome and on which he represented the Japanese banks with distinction until he was succeeded by Mr T. Naruse, also of the Bank of Tokyo, in December 1989.

Mr Naruse was succeeded in February 1991 by Mr

H Matsudaira of the Dai-Ichi Kangyo Bank, who was followed by Mr M Hamomoto, also of Dai-Ichi Kangyo in March 1991. Mr Yoshimoto, Fuji Bank succeeded him in November 1992 and he was succeeded in turn by Mr H Takanaka of the Industrial Bank of Japan, in May 1993. Mr S. Uno of the Mitsubishi Bank took over in 1994, and was succeeded in 1995 by Mr S. Minamimato of the Sakura Bank. Of the three foreign members of the eighteen-strong Council, one is Japanese, one American, and the third is nominated by the Foreign Banks & Securities Association

London Investment Bankers Association
[formally British Merchant Bankers Association]

The British Merchant Bankers Association was formed at the time of Big Bang in 1986 to take account of the fact a number of foreign financial institutions were planning to become major players in the London capital market. The decision was taken to form a trade association to represent the interests of the major merchant banking and securities firms in the market, regardless of ownership. The broad objective of the association was to ensure that London remained a favourable location in which to conduct wholesale financial business.

In view of the prominent role which a number of Japanese firms then had in London capital markets business, it was regarded as important to secure the participation of such Japanese firms in BMBA. An informal approach was made to the Japanese Embassy to explain to the Ministry of Finance the nature of the association and the standing which it was expected to have in the City. With their goodwill, approaches were then made to leading Japanese houses, inviting them to join.

The first Japanese members of BMBA were Daiwa Europe Ltd and Yamaichi International (Europe) Ltd, who

both joined on first July 1988. They were followed shortly after by Nomura International plc and by Nikko Europe Ltd. Other Japanese houses have had brief memberships to explore its relevance to their business, but these large firms have remained stalwart members. They were joined in 1993 by Tokai Europe Ltd consequent upon the expansion of its capital market business. Representatives of Japanese members are active in a number of the committees through which the association – now re-named the London Investment Bankers' Association – carries out its role.

The London Stock Exchange

'Big Bang' in 1986 opened the Stock Exchange in London to foreign participants, and in that year the 'Big Four', Nomura, Nikko, Yamaichi and Daiwa were admitted to membership via their London-based subsidiaries. Three smaller firms, New Japan, Wako, and Kankaku followed in 1988; the Industrial Bank of Japan's brokerage subsidiary, IBJ International joined in 1989, and Tokyo Securities in 1990.

From the very beginning it was felt that there should be a Japanese representative on the Council of the Stock Exchange – which after October 1991 was renamed as the Board. Mr Hitoshi Ishihara of Yamaichi International (Europe) Ltd was the first to serve in this capacity. He was succeeded in turn by Mr Nobuo Nakazawa of Nomura International plc, Mr Masao Inagaki of Nikko Securities (Europe) Ltd, Mr Koichi Kane, again of Nomura, and Mr Masashi Kaneko of Nikko, the last named starting his term on the Board in July 1994.

Activity in Japanese securities has in, recent years added enormously to the volumes of trading in London.[1] In 1994, of all foreign securities traded on the Stock Exchange in London, Japanese stocks were the largest sector, with £165

billion of trading, compared with a figure of £429 billion for all European equities, and accounted for 23 per cent of all foreign equity turnover in London. That figure of £165 billion was 30 per cent of turnover in Tokyo of £559 billion. Japanese companies in 1994 accounting for thirty nine out of the one hundred largest listed or quoted companies in London, as measured by equity market value.

London International Financial Futures Exchange

The Japanese financial community, as a whole, was not particularly influential in the actual establishment of LIFFE. However, the fact that they were prepared to join LIFFE 'en masse' when the Exchange was established was a particularly important structural point. LIFFE was keen to promote the 'international' image of itself and its market from the outset and the commitment of both the Japanese banks and securities houses was a key part of this concept. At the inception of LIFFE in 1982, there were thirty five Japanese members, twenty seven of which remain members today. Activity from the Japanese members increased in 1987 when the Exchange was gearing up to list the Japanese Government Bond contract. Of the 203 members of LIFFE, about 20 per cent are Japanese financial institutions (forty two members). There are currently no Japanese member firms represented on the Board of LIFFE (in fact, no Japanese member firm has ever been represented on the LIFFE Board). There is, however, one representative on the Membership & Rules Committee (Mr M. Kawamura from Bank of Tokyo Capital Markets Ltd). The Japanese community appears to want to take a back seat in formal governance, but they are very much involved in the informal consultative problem which is a constant feature of Exchange decision making.

The LIFFE Japanese Government Bond contract (JGB)

was initially listed 13 July 1987 and was traded in the open outcry environment on the trading floor. The contract was not successful in this form and, consequently, a link was established with the Tokyo Stock Exchange to enhance liquidity. This 'new' linked JGB contract was established in April 1991 and since that date has been traded on LIFFE's computerised trading system (APT) from 07:00 to 16:00. The attached graph shows the volume of the contract since inception, and illustrates clearly the growth since the re-launch. The Tokyo Stock Exchange (TSE) obviously has the majority market share, being the mother market, although LIFFE has steadily increased its share over the past three years. SIMEX introduced a JGB contract in 1993, with the major difference being that the nominal value is half that of the LIFFE and TSE contracts. Consequently, when comparing volume figures, one must remember that each LIFFE and TSE contract is worth two SIMEX contracts. The SIMEX JGB contract competes directly with the TSE contract, as the two Exchanges are situated in the same timezone. The LIFFE JGB contract has become a commonly used out-of-hours hedging vehicle for market participants world-wide, and is used particularly to execute calendar spreads, a strategy which is not possible in Tokyo. The Japanese members have a very strong APT presence and about half of them have one or more screens in their offices. There are six Japanese members with a trading floor presence. There has only ever been one Japanese floor trader on LIFFE (Mr Sitow of the Bank of Tokyo) and this was in 1982 when the Exchange opened.

On 11 April 1996 the LIFFE/TIFFE link went live. This is one of the co-operative ventures with Exchanges in other time zones being developed as part of LIFFE's strategic objective to remain the leading international futures and options market. This enables trading in Euroyen futures on the LIFFE Floor each day after the close of

TIFFE (Tokyo International Financial Futures Exchange). The Euroyen futures contract is the second highest volume money market instrument in the world after the Eurodollar.

LIFFE Japanese Members

Almost 20 per cent of LIFFE's membership is from Japan.

Bank of Tokyo Capital Markets Ltd
The Bank of Tokyo Ltd
The Bank of Yokohama Ltd
The Chuo Trust & Banking Company Ltd
The Daiwa Bank Ltd
Daiwa Europe Ltd
Dai-Ichi Europe Ltd
The Dai-Ichi Kangyo Bank Ltd
Fuji International Finance plc
The Fuji Bank Ltd
IBJ International plc
The Industrial Bank of Japan Ltd
Kankaku (Europe) Ltd
Kokusai Europe Ltd
The Asahi Bank Ltd
The Long Term Credit Bank of Japan Ltd
Mitsubishi Finance International plc
The Mitsui Trust & Banking Co., Ltd
Million Trading Company Ltd
Mitsubishi Trust International Ltd
The Sakura Bank, Ltd
The Mitsubishi Bank Ltd
Nikko Europe Ltd
The Nippon Credit Bank Ltd
New Japan Securities Europe Ltd
Nomura International plc

JGB Futures Annual Volume (LIFFE & SIMEX)

Source: LIFFE

JGB Futures Annual Volume (TSE)

Source: LIFFE

Spread of Involvement – The Good Citizens 101

JGB Futures Monthly Volume (LIFFE) July 1987 to December 1995

Okasan International (Europe) Ltd
Sanwa Futures L.L.C.
Sumitomo Finance International plc
Sanwa International plc
Sumitomo Trust International plc
The Sumitomo Bank Ltd
The Sanwa Bank Ltd
Tokai Bank Europe Limited
The Tokai Bank Ltd
Toyo Trust International Ltd
Yamaichi International (Europe) Ltd
Yasuda Trust Europe Ltd

SUPPORTING SERVICES – INSURANCE, ACCOUNTANCY AND SHIPPING

Insurance
(non-life)

Japan's links with the Insurance Industry in the City of London dates from 1861, when Imperial Fire Insurance (later to merge with Alliance Assurance), appointed agents in Yokohama.[2] In that year, the first edition of the English language newspaper, the *Japan Herald*, carried an advertisement placed by Imperial Fire.[3] It was soon followed by Phoenix Fire Assurance, Commercial Union Assurance, London & Lancashire Insurance, and Union Insurance. The first fire insurance policy in Japan was probably the entrepot (bonded warehouse) policy at Yokohama Customs, underwritten in 1866 by seven British insurers. In 1870, Royal Exchange Assurance[4] appointed agents in Yokohama, and in Kobe in 1887. It is notable that, of the first twenty one foreign insurance firms to establish agents in Japan, nineteen were British, and two Dutch. The earliest evidence of Japanese use of British marine insurance seems to be a newspaper advertisement in 1876 by agents acting for Merchants Marine Insurance indicating that they were insuring 'steamships of the Mitsubishi Company and other concerns against marine risks'.[5]

The Japanese marine insurance industry originated with Tokio Marine, now the largest general insurer in Japan, if not in the world. It was founded in 1879, and took over the marine insurance business initiated by Dai-Ichi National Bank in 1877 to underwrite cargoes, for which it drew documentary bills. Tokio Marine started writing hull insurance in 1884, and was soon attracted to London which, in the 1880's and 1890's, was already the world's largest centre for the leading companies and experts

in non-life insurance, transacting over half the world's business.

Tokio Marine, in 1890, appointed agents in London, Liverpool and Glasgow, but its activities were soon to be entirely concentrated in London where its hull insurance business expanded rapidly. In 1894, it sent one of its key men, Kengichi Kagami[6] to London and, on his advice, Willis Faber & Co, the leading marine insurance brokers in London, were given Tokio Marine's underwriting agency. The Kansai region of Japan, which includes Osaka, Kobe and other cities, was then the centre of Japan's shipping industry; Tokio Marine was now able to write hull and cargo insurance policies with prime shipowner customers in the Osaka-Kobe area, reinsured in London, with Willis Faber placing the risks.

The Japanese fire insurance industry started later than marine insurance, with the founding, in 1887, of the Tokyo Fire Insurance Company (much later to become part of Tokio Marine).[7] It was followed by the Fire Insurance Union later to become Meiji Fire Insurance in 1891. The latter had a relationship with Phoenix Fire Insurance of London, with whom it reinsured various risks. Mitsui & Co. also became agents for Sun Fire Office, the London & Lancashire Insurance and others, for fire insurance and the insurance of spinning plants.[8]

War with Russia in 1904 presented Japanese marine insurers with a number of problems on the acceptance of war risks. In particular, when it became known, in October 1904 that the Russian Baltic fleet (upon which the Russians relied to retrieve their Far East misfortunes) had set sail for Japan, there was frenzied activity; Tokio Marine's clients were calling in the middle of the night to apply for war risk cover. The company had no experience of war insurance, but proved successful in placing necessary reinsurance of war risks, by daily cable in the London market.[9]

To,

ADMIRAL, HIS IMPERIAL HIGHNESS,

PRINCE YORIHITO OF HIGASHI-FUSHIMI.

MAY IT PLEASE YOUR IMPERIAL HIGHNESS
WE, THE LORD MAYOR, ALDERMEN AND COMMONS, of the City of London in Common Council assembled, offer you a most cordial welcome on the occasion of your visit to this Country as the representative of His Imperial Majesty the Emperor of Japan, the illustrious Ally of our beloved Sovereign.

The Anglo-Japanese alliance has now existed for upwards of 16 years, it has been tried, and not found wanting, both in peace and in war, it safeguards the interests of England and Japan not only in the Far East but throughout the world, and bears eloquent testimony to the wisdom and foresight of the Statesmen of both Countries.

The Citizens of London watched with deep interest the steps which Japan at once took on the outbreak of war to protect not only their own, but also British, interests in the Far East, by the brilliant feat of arms which resulted in the capture of the German outpost of Kiao-chau, and the loyal assistance given to the Allies by the Japanese Imperial Navy in the Mediterranean and in the Indian and Pacific Oceans. The insurrectionary movement in Russia has called for prompt intervention in Siberia, and in the military operations there your magnificent Army is playing a great part.

We would also express our pleasure and gratification at the cordial and enthusiastic reception given by all classes of your people to His Royal Highness, Prince Arthur of Connaught on the occasion of his recent visit to Japan to present, to your Illustrious Sovereign, on behalf of His Majesty the King the baton of a British Field Marshal, which is the highest Military honour it is in the power of His Majesty to bestow.

In conclusion, the Citizens of London, in doing honour to the representative of your Illustrious Sovereign, desire to express the fervent hope that the Empire of Japan, which has existed for so many ages, may enjoy in the future continued happiness and prosperity.

SIGNED by Order of the Court,

JAMES BELL,

Town Clerk.

1 Address presented to Admiral H.I.H. Prince Yorihito, Guildhall, November 1 1918, signed by James Bell, Town Clerk, Corporation of London. *Guildhall Library. Reproduced by kind permission of the Corporation of London, Records Office. (Ent.s.b.1918-21)*

2 Dinner at the Holborn Restaurant, December 1934, to celebrate the 50th Anniversary of the opening of the Yokohama Specie Bank's London office, Chairman Mr H. Kano.

3 'Hats off to the City', c1937, Prince Chichibu-no-Miya (centre), visiting the Yokohama Specie Bank's London office at 7, Bishopsgate (now The Bank of Tokyo).

4 'Out of Hiroshima – A Symbol of Hope and Reconciliation, 1950'. The Mansion House, London. Left to right: The Lord Mayor of London, Sir Frederick Rowland, The Mayor of Hiroshima, Mr Shinzo Hamai. The Mayor of Hiroshima presents to the Lord Mayor of London a cross carved from the wood of a 400 year-old camphor tree, planted at the time of the founding of the City of Hiroshima. The outside of the tree was destroyed by the bomb, but the heart of it was still sound. *Guildhall Library. Reproduced by kind permission of the Corporation of London, Records Office. (P.D.58.2)*

5 H.M. The Emperor of Japan speaking in Guildhall, October 1971, at the State Banquet given in his honour by the Corporation of London. Left to right: H.R.H. The Duchess of Kent, H.M. The Emperor of Japan, Sir Peter Studd, G.B.E., Lord Mayor of London. *Guildhall Library. Reproduced by kind permission of the Corporation of London, Records Office. (Print C.194)*

6 Dinner at The Mansion House, 26th February 1981, to celebrate the centenary of The Bank of Tokyo. Far side from right to left: Sir Julian Ridsdale, Lord Roll of Ipsden, H.E. Mr Naraichi Fujiyama (Ambassador of Japan), Colonel and Alderman Lord Mais (former Lord Mayor of London), Mr C.W. McMahon (Deputy Governor, Bank of England), Sir John Pilcher (Former Ambassador to Japan).

7 Official opening of Finsbury Circus House, March 1992, by The Right Honourable The Lord Mayor, Sir Brian Jenkins, G.B.E. Left to right; Mr Tasuku Takagaki (President, The Bank of Tokyo, Ltd.), H.E. Mr Hiroshi Kitamura (Ambassador of Japan), The Lord Mayor, Mr E.A.J. George (Deputy Governor, Bank of England).

8 The author with Prime Minister Morihiro Hosokawa, Tokyo, March 1994.

In 1906, the Kobe Insurance Company decided to explore the possibilities of arranging their reinsurance treaties in London. An introduction was made to C.T. Bowring & Co,[10] another leading London insurance broker, who duly sent Sidney Townsend to Japan as Bowring's first representative there. By 1908, he had secured the Kobe company's extensive cargo and hull reinsurance business, which was duly placed in London. At about the same time, Bowring's secured similar business from the Nippon Fire and Marine Insurance, which had been founded in 1896.

World War I occasioned an even greater increase in marine insurance business. The ability of a Japanese insurance company to profit from the boom caused by the war depended almost entirely on the capabilities of its London agency. In 1915, OSK, Japan's second largest shipping company, decided to create its own marine insurance company (which was to be named Osaka Marine and Fire Insurance in 1917). OSK sent Shozo Murata, later to be President of Osaka Marine to London, and he secured an insurance agreement with the brokers Sedgwick, Collins & Co in 1916.[11] The reinsurance cover for both marine and fire arranged by Sedgwick enabled the Japanese company to grow rapidly; it leapt from a ranking of fifteen out of twenty three Japanese marine insurance companies, as rated by premium income, in 1915, to second place in 1917, (a position which it held until 1926).

In 1918, Taisho Marine and Fire (later to become Mitsui Marine & Fire) was formed out of Mitsui & Co's Insurance Department and, in 1923, concluded an underwriting agreement with Willis Faber. Taisho's first resident representative in London was Sakumo Nobuyoshi,[12] who, with the help of Mitsui & Co's London office established Taisho's status sufficiently well as to be able to persuade Willis Faber to grant an increase of reinsurance limits for

marine insurance, and to arrange a reinsurance treaty for fire insurance as well. Also, in 1918, Fuso Marine and Fire Insurance (later to merge with Osaka Marine), made an agency contract with Hartley, Cooper & Co of London to underwrite marine insurance, and opened an office in the Lloyds Building in the 1920s, switching to a joint underwriting system with General Accident Insurance. It also accepted business from Commercial Union, Sun Insurance and General Accident in marine and fire. The results of these latter treaties were, for the most part, unsatisfactory and in 1930 the company's reinsurance operations were halted and the direct underwiting business was scaled down.[13]

In the 1920s Bowrings sent another emissary to Japan, Edward Stevenson, and Kobe Insurance then invited Bowrings to place fire insurance treaties in London for them, and, throughout the decade, the major Japanese companies continued to build agreements in London. For example, Mitsubishi Marine and Tokio Marine were able to participate, via reciprocal treaties, in marine and fire insurance in the British and European markets. Agency contracts with Willis Faber, and treaty exchanges with Norwich Union, Atlas Assurance and other companies made this possible.

The great Kanto earthquake of 1923 caused vast damage, with fires devastating Tokyo and Yokohama. Great pressure was put on the Japanese insurance companies by their Government to settle claims arising from the earthquake, despite the fact that the conditions for fire insurance at the time excluded loss or damage occasioned by, or in consequence of earthquake. Most of the policies involved were reinsured in London, and the London underwriters formed a special committee whose members were sent to Japan to process the claims filed. The reinsurance payments were duly made without any trouble, but the twenty eight

foreign companies who had directly written policies on earthquake-damaged properties refused payment.

Marine insurance became less profitable in the mid-1920s, following the Showa Depression, and an increasing number of marine insurers turned to fire insurance; Taisho Marine, in particular, was heavily influenced by a mammoth report sent by their man in London, Nobuyoshi, entitled 'The Fire Insurance Business in Great Britain', acknowledging that the whole concept of fire insurance originated from the Great Fire of London in 1666. The Japanese marine insurers continued to work with London however, and when in 1927, they formed the Hull Insurers Union, many of their fleets were being coinsured by British underwriters. The increasing restrictions placed in the 1930s by the Japanese Government on payments in foreign currency led to a substantial decline in insurance business with London by World War II. Although, in 1937, over 50 per cent of marine and fire reinsurance business was still being placed in London, by 1941, nearly all had been redirected to the domestic market. Such business was, of course, non-existent until after hostilities had ceased, but the bonds of business trust and friendship, so carefully nurtured for very many years, enabled the major London insurance brokers to reestablish their Japanese reinsurance business a few years after the war ended.

The first post-World War II contact between the London market and Japanese insurance companies occurred in 1947, when a delegation from London visited Tokyo. Companies such as Willis Faber and Sedgwick Collins were able to reestablish their traditional relationships. In 1950, the resumption of foreign currency-denominated marine cargo insurance again made possible reinsurance coverage in London and Osaka Sumitomo Marine (as it was now called) established such cover through Sedgwick Collins.[14] In the same year a new agreement was established between

Tokio Marine and Willis Faber on surplus treaties for domestic direct writings,[15] and Mr Tanaka, President of Tokio Marine, was welcomed in London at a party sponsored by the Fire Offices Committee ending with an impromptu gathering of nearly twenty of London's first-class underwriters. By 1951, Tokio Marine had concluded an outgoing hull treaty in London through Willis Faber, and was negotiating an early resumption of reinsurance business in overseas markets generally.

The reexpansion of the overseas business interests of many Japanese insurance companies was considerably speeded by a revival of overseas training programmes for promising employees. Tokio Marine had adopted such a strategy as early as 1908, and Meiji Fire and Mitsubishi Marine had, later, followed the same path. In 1952, a visit to Japan by Lex Douglas-Whyte[16] of Willis Faber persuaded Tokio Marine executives to restart the process, and, in the following year their trainees arrived in London. By 1953, the renewed relationship was further confirmed when Osaka Sumitomo Marine & Fire appointed Sedgwick Collins as their UK agents,[17] and in 1954 the company, now renamed Sumitomo Marine & Fire, sent Mr K. Itoh (later to become President of the Company) to London for training, followed by Mr H. Oguri. These were the forerunners of a long succession of representatives who returned to Tokyo, eventually to take up senior posts. In 1953, Taisho Marine also reestablished their presence in London and were given space by Willis Faber, as their predecessors had been before World War II; in 1956 they established an agency for direct underwriting in London, with Willis Faber as their sole agents.[18] Daiichi Mutual Fire & Marine also appointed Sedgwick Collins as their UK agents in 1957.

Several Japanese insurers established their own agencies in London in the 1950s and 1960s in an attempt to become multinational via direct underwriting abroad.

Tokio Marine entered the United States and European markets in 1956, appointing Willis Faber & Dumas as 'General Managers for the United Kingdom and Europe'. Such experiences were not always profitable, and many companies subsequently withdrew from that business, although there are some recent signs of a revival of interest in this field. The London connection, however, was helpful in other ways; some of the new products established at home by Japanese companies in the 1960s such as profits insurance (indirect loss of earnings) were based on examples and precepts from the British Insurance Industry, and Taisho Marine was notable in developing that particular line of business.[19] In 1964, Taisho Marine was the first Japanese company to issue shares of its stock in London Depositary Receipt form on the London Stock Exchange; this was regarded at the time as recognition that London was the centre of the international reinsurance market.[20] The issue was arranged in London through Hambros Bank, with Cazenove & Co acting as brokers. As far as reinsurance was concerned, the burgeoning economy of Japan in the 1960s led to demand for a substantial increase in earthquake capacity, and the London reinsurance brokers of the Japanese companies concerned were very successful in finding such capacity.

Sumitomo Marine & Fire was one of the Japanese companies in the 1970s which sought to provide more than just insurance services for their Japanese clients, and to participate directly in the London market. Some substantial losses were experienced, in common with other companies, but, by the late 1970s, it was evident that future expansion of European business was in prospect, coincident with future standardisation of E.C. regulations governing insurance companies, and, with that in mind, Sumitomo Marine & Fire established a wholly-owned subsidiary in 1976, Sumitomo Marine & Fire Insurance (Europe) Ltd.

In the 1980s the international operations of the Japanese non-life companies developed apace as their corporate clients broadened their overseas presence. Indeed, the total funds held by these insurers expanded 4.4-fold between 1979 and 1991.[21] Asset management and risk management became increasingly important for them, as did geographical diversification of investment. Over the same eleven years, the proportion of the Japanese non-life industry's overseas investments increased from 2.7 per cent to 15 per cent. After the earlier oil crises, Japanese industrial manufacturers had speeded up their moves to overseas locations, and as a result, exclusive agreements for reinsurance, such as that between Sumitomo Marine & Fire and Sedgwicks became less attractive. The former duly set up its own International Reinsurance Department in 1983 and, in 1987, dissolved the agreement with Sedgwicks which had originated in 1916.[22] The amicable relationship remained, however, as did the overall level of reinsurance business with Sedgwicks.

Sumitomo signed a reciprocal cooperation agreement in 1990 with Guardian Royal Exchange in 1990, thereby formalising an arrangement already in place for twenty years. Both companies agreed to exchange technical advice, staff training, reinsurance, and the introduction of insurance that each is unable to write in the other country. The principle reason behind the agreement was for GRE to provide technical help and support, combined with underwriting capacity to allow Sumitomo to provide local protection to their Japanese global clients with business interests in the UK.

Today, the Japanese non-life companies base their European regional headquarters in the City of London. From there they insure their clients throughout Europe, utilising British Insurance brokers to provide distribution and service. Nissan Fire & Marine and Yasuda Fire & Marine

are also corporate members of Lloyds, whilst Chiyoda Property & Casualty and Tokio UK actively underwrite in the UK market. Taisho Marine & Fire (Europe), also based in the City, maintains close links with the Sun Alliance and Tokio Marine have an arrangement with the Commercial Union (where they own approximately 2.4 per cent of the equity), the latter underwriting marine and aviation business on their behalf. Other Japanese have representative offices in the City to maintain contact with the London market. insurers such as Nisshin Fire & Marine and Taisei Fire & Marine.

For these Japanese insurance companies, the City of London remains an important centre for reinsurance, with many of them maintaining the business links with brokers and insurers that have been created over many years.

Accountancy

The 1,000 or so Japanese companies engaged in business in the United Kingdom need, as do all multinational companies, professional services with global capability. In most cases, their auditing requirements are met by the Big Six London-based firms of chartered accountants. All of the latter have, of necessity, developed alliances of differing nature with Japanese accountancy firms.

The first British firm to establish such an alliance was Touche Ross & Co, at a time when the Japanese accountancy profession was very fragmented. However, in 1975, the Tokyo-based accountancy firm of Tohmatsu had offices throughout Japan, and also in New York, Hawaii and Los Angeles. Touche Ross International, who had their own office in Tokyo, recognised that Tohmatsu was probably the most internationally oriented of the Japanese accountants, and a merger was agreed. Tohmatsu took over the Touche Ross office, in

Tokyo, and at the same time became an integral part of Touche Ross.

Today, the organisation, now styled Deloitte & Touche acts as official auditors to about 25 per cent of all Japanese companies in the United Kingdom, including over 50 per cent of the Japanese banks in the City of London. KPMG come a close second in size in the UK in providing accountancy services to Japanese corporate clientele, and Ernst and Young are linked with Showa Ota & Co under a somewhat similar arrangement.

Shipping

The importance of London as a global maritime centre was another factor which encouraged Japanese traders of all kinds, insurers and shipowners to come there. In the late 19th century, Britannia indeed ruled the waves in peace as in war, with more than half the world's shipping fleet.

Thus London became, and remains, in spite of a shrunken fleet, the prime centre for international shipping activity because of the critical mass of domestic and international shipping organisations of all types which have their base in that city. Fifty per cent of the world's shipbroking business is still conducted through London's Baltic Exchange, with its 1,600 shipbroker members. London remains the biggest centre in the world for marine insurance and reinsurance, with Lloyds of London the leading underwriting centre for marine risks. Lloyds Register of Shipping remains the world's largest ship classification society. Although the centre of gravity in international shipping is moving from Europe to the Asia-Pacific region, as has shipbuilding, the major international shipping agencies remain mainly centred in London. The United Nations' specialist maritime organization (IMO) has, since the late 1950s, been based in London.

The Japanese Shipowners Association (JSA) was a founder member of the International Chamber of Shipping (ICS) in 1921. The latter was then known as the International Shipping Conference, the name being changed to its present form in 1948. For obvious reasons Japanese membership was suspended during World War II; a formal application to rejoin was received in December 1956 and accepted with effect from April 1957. Following their re-admission, the JSA soon became fully involved in ICS and was represented on its Executive Committee from 1960-2. In 1969 the JSA was once again elected to the Executive Committee and has been continuously represented since then. The current JSA representative is Mr Tsuguji Yamaguchi (NYK Lines [Europe] Ltd). The JSA has historically been an active member of ICS and currently participates fully in all of its committees and sub-committees almost entirely through the JSA London office, in Royal Mint Court, reporting directly to Tokyo.

The Council of European and Japanese National Shipowners Associations (CENSA), which developed from the Committee of European Shipowners (CES), is concerned with international aspects of shipping policy and is administered by a small international secretariat, based in London. The membership contains shipowners associations for thirteen European nations, and the Japanese.

In the 1950s the Americans tightened the regulations contained in the US Shipping Act of 1916 known at the Bonner Act;[23] this led to a lengthy and sometimes acrimonious dispute with international shipping interests, and to the need for a single European committee to discuss common problems. This was to be joined by Japanese interests through their own shipowners association – the only non-Europeans to be represented. US regulatory activity, including enactment of the Bonner Amendments in 1961 soon led to European and Japanese governmental

involvement, in a desire to protect their shipowners and traders from adverse developments arising from what was seen as an excess of regulatory zeal in the United States.[24] Thus emerged the Consultative Shipping Group of Governments an informal yet cohesive group which met in London in 1963, in Tokyo in 1971, and is still very active.

London remains the centre for all services to the international maritime community of which the Japanese are a very important part.

THE SOCIAL CONTEXT
CHARITY, FOUNDATIONS AND EDUCATION

The Corporation of London continued to play its supportive part in entertaining and honouring distinguished Japanese who visited Britain, and in giving recognition to the Japanese presence in the City of London. In 1981, the Lord Mayor, Sir Ronald Gardner-Thorpe hosted a Reception in the Mansion House to mark the Centenary of the Bank of Tokyo. The significance of the Japanese presence in the City was highlighted further in 1987, when Lord Mayor Sir Greville Spratt invited Nomura to enter a Japanese float in the Lord Mayor's Show, and in 1988 hosted a Luncheon given by the Corporation for Prime Minister Takeshita when the latter visited Britain as a 'Guest of Government', together with Madame Takeshita.

The Japan Society celebrated its Centenary Year in 1991. It had continued in existence up to the outbreak of hostilities in World War II, had been revived in 1949, and had re-established itself as the leading organisation in Britain devoted to the promotion of better understanding between the two countries. To mark the occasion, the Society, with Sir Hugh Cortazzi as Chairman of the Council helped to organised 'The Japan Festival in the United Kingdom'. Mr Shoichi Saba, Vice-Chairman of the Keidanren was Chairman of the Festival, with Sir Peter Parker.

It included many aspects of Japanese life, especially business, food, films, dance, music and architecture. The Corporation of London, to celebrate and help promote the Festival's opening, gave a Reception in Guildhall, hosted by the Lord Mayor, HIH The Crown Prince of Japan being the principal guest.

In 1992 the then Lord Mayor, Sir Brian Jenkins officially

opened the Bank's new premises in Finsbury Circus, and in 1994 leading Japanese banks were each invited to nominate two Japanese children to attend the Annual Children's Fancy Dress Party at the Mansion House, hosted by me and my Lady Mayoress.

As employers, many Japanese have been meticulous in building links within London and within the other communities in which they work. They take part in Business in the Community-type programmes, have sponsored research and development establishments, sports events and musical performances, and generally been good corporate citizens.

They have been generous in their endowments. In 1987, Nomura donated $2.5 million to the building of the new extension to the Tate Gallery. The biggest single benefaction by any Japanese company has been the £20 million establishment of the Daiwa Anglo-Japanese Foundation in 1988 by Daiwa Securities. The Daiwa Foundation, on the initiative of Mr Yoshitoki Chino, the then Chairman, had as its aims the enhancement of Anglo-Japanese understanding, scholarships, enablement of further education for British and Japanese students and academics, and the provision of grants to charities engaged in education or research in the UK or Japan. The Daiwa Foundation Japan House opened in Cornwall Terrace in 1994 as a focus and meeting place for those with an interest in Japan and Anglo-Japanese relations.

The Great Britain Sasakawa Foundation, named after a philanthropic Japanese shipping magnate, Mr Ryoichi Sasakawa and founded in 1985, also funds, inter alia, educational, sociological and cultural programmes aimed at strengthening Anglo-Japanese interrelationship. The Suntory and Toyota International Centre for Economic and Related Disciplines, established in 1978, (STICERD) was originally endowed in the sum of £2 million and there

have been many other examples of charitable sponsorships, grants and research fellowships funded by Japanese companies with a presence in the United Kingdom.

Academic links have been mutually advantageous. The City University has run induction programmes for newly hired graduates at Daiwa Securities to enable them to learn about the institutions and structures of the City of London. Staff have been provided to lecture in Nikko's induction programmes and in their staff development. Dr Andreas Prindl, Chairman of Nomura Bank International, has enhanced the City University's management development programmes by speaking to non-Japanese audiences about the Japanese presence in the City. Gyosei College in Reading, a Japanese foundation, privately endowed by a Japanese benefactor, Mr Takashi Nozu, of the Nozu Group of Companies, have funded a chair and a lectureship at the City University on International Business Policy and Commercial Law respectively. The Tokai Bank have funded a Professorship of Finance at the London Business School and another at Birmingham University.

'TWO STRONG MEN'

London is now the European headquarters not just for Japanese financial houses but for virtually all the major trading houses and contractors, as well as for the Japan Development Bank and the Export-Import Bank of Japan. The relationship to the City of London is but one of many spheres in which closer commercial links are being forged in global trade, and in joint programmes and alliances in Third World Development. A recent publication 'Japanese Business in the UK' also describes London as 'the strategic news reporting base for Europe', and the Japanese state-owned TV corporation NHK has now moved its European headquarters from Paris to London. The leading

Japanese newspaper 'Asahi Shimbun' has for the past ten years, been printed in London.

It is interesting to speculate on the degree to which 'the London culture' has been shipped back to Japan by the number of senior executives who have served in London or have directed their firms' pan-European activities from an office in the City. Many of these have become the leaders of their respective institutions, and their London experience has clearly been formative in the defining of their global policies as directed from Tokyo.

The full extent of the Japanese involvement in the City of London, and their participation in, and contribution to, its markets and services has, perhaps, not been fully recognised in the past. Beyond any doubt, they are very substantial participants in the London financial scene, both as conscientious employers and keen participants in the City's institutions. They undoubtedly feel more 'at home' in London than elsewhere in Europe; the United Kingdom in general and London in particular have benefited greatly from their presence. London's predominance in Europe as a money centre is fully recognised by them, and they have contributed handsomely to that predominance. Their long-term commitment to London and the multitude of links with their British business counterparties and employees have transformed Japanese-British relationships at every level. In the City, an increasing number are being encouraged to join its Ward Clubs, and other social and business clubs; it is a happy relationship.

The distinguished writer on that relationship, Christopher McCooey, in an article written in 1992 appropriately summarised the strong affinity between the two countries, by quoting from one of Rudyard Kipling's ballads:-

'Oh East is East and West is West
And never the twain shall meet
Till Earth and Sky stand presently
At God's great Judgement Seat.
But there is neither East nor West,
Border nor Breed, nor Birth
When two strong men stand face to face
Though they come from the ends of the earth.'

Ten Brief Histories
Some Leading Japanese Firms
In The City

(alphabetically considered)

- Dai-Ichi Kangyo Bank
- Daiwa Securities
- Fuji Bank
- Industrial Bank Of Japan
- Mitsui & Co
- The House Of Nomura
- Sakura Bank
- Sumitomo Bank
- Bank Of Tokyo
- Bank Of Yokohama

THE DAI-ICHI KANGYO BANK (DKB)

The Dai-Ichi Bank, formed in 1872, was the first to be established under the National Bank Act of 1872. It was empowered to issue bank notes until the Bank of Japan assumed that function in 1883. The Nippon Kangyo Bank, with which Dai-Ichi Bank was to merge in 1971, began business in 1897 as a government institution providing long-term industrial and agricultural loans, becoming a commercial bank in 1950.

Both of these banks absorbed other banking institutions over the years, and were large enough to expand internationally in the 1960s, especially as so many Japanese corporate clients were establishing their presence in Europe. Dai-Ichi Bank opened its London Branch in March 1965 and the Nippon Kangyo Bank followed suit shortly thereafter. Initially, activities in London were concentrated on providing advice and financial services to the small but growing number of Japanese manufacturing and trading subsidiaries in Europe and the UK, but these led on to increasing participation in London's financial markets.

In the early 1970s, a joint-venture bank, Dai-Ichi Kangyo Paribas Ltd was established, with Dai-Ichi Kangyo owning 70 per cent of the equity, and Paribas 30 per cent. This was typical of several joint venture banks in London at the time, to raise funds on the Eurodollar markets and to engage in securities underwriting. In 1977, Dai-Ichi Kangyo acquired total ownership, and the institution was renamed DKB International plc. Two other UK subsidiaries have been established since then, namely DKB Investment Management International Ltd. and DKB Financial Products Ltd. Through these subsidiaries, the bank engages in securities underwriting and trading, fund management and derivatives business. The bank's main activities in London cover a wide range including

international treasury, UK corporate loans, project finance, aviation finance, syndicated loans and financial services for Japanese, UK and other European corporate clients; the London branch is by far the largest of the bank's European offices, employing 370 in the City of London alone compared with 680 in the whole of Europe. The bank states that its principal banking areas, the securities business and international treasury operations in London are being expanded. It has concerns about London's transport infrastructure and management has also commented with regard to regulation that 'the UK appears to take its obligations to implement relevant EC directives in this area more seriously than some of its EC partners'.

The Dai-Ichi Kangyo Bank is now one of Japan's largest commercial banks, with 74 offices in 29 countries abroad. At home, it is the only bank to have branches in every prefecture in Japan, forming a network of 400 branches, receiving the largest number of customer visits (about 200 million) annually among Japanese banks. In the fiscal year ended March 31 1995, the bank took active steps to confront the problem of non-performing loans, a problem common to all the Japanese banks, by writing down doubtful loans and increasing its loan-loss reserves. The April 1993 enactment of the Financial System Reform Law enabled DKB to launch its wholly-owned securities subsidiary in November 1994, DKB Securities Co Ltd, and the bank also plans to launch a trust banking subsidiary, following authorisation from the Ministry of Finance.

DKB now ranks second in the world in terms of assets, totalling over $600 billion as at March 31 1995. It is very much committed to the further expansion and development of its London branch, which will remain at the forefront of its European operations.

DAIWA SECURITIES

Founded in 1902 and now one of the 'big four' Japanese brokerage firms, Daiwa Securities was one of the first to open an office in the City of London, on April 1 1964 at Swan House, Queen Street. Conditions, by modern standards were not easy, particularly in the field of communications. Instant information from Japan could only be obtained by short wave radio and there was a three day waiting period before Japanese-language newspapers could be read. Although market information was available by telex, it was impossible to predict when such communication could be obtained from the London end of the line. In 1964, there was no Japanese school, one Japanese restaurant and two Japanese grocery shops to service the 2,000 Japanese residents registered with their Embassy. Over the next five years there was a 50 per cent increase in the numbers registered but the number was well short of the 56,000 today.

1970 was an important year for Daiwa Securities in London. The office was upgraded to branch status, moving to City Wall House in Chiswell Street; equity business was now expanding rapidly and, indeed, Daiwa Securities claim to have accounted for 40 per cent of the total brokerage in Japanese shares in Europe in the period 1970-5. The company proved adept in handling large blocks of shares, essential for institutional business, with minimum disturbance of the market. Daiwa's underwriting activities in Europe were also developing at that time and it lead-managed or participated in the underwriting syndicates for the NEC (Nippon Electric) and the Mitsubishi dollar bond issues. It was thus able to demonstrate its placing power in Europe and expanded its operations further by opening representative offices in Frankfurt in 1969 and Amsterdam in 1971.

Daiwa was one of the brokerage houses to be active in seeking a licence to establish a banking subsidiary in London; the difficulties involved with this process are explained more fully in a previous chapter. With a view to setting up a legal framework for banking operations as soon as authorisation was given, Daiwa reregistered its London office as a branch of its Dutch subsidiary. In September 1973 therefore, the London branch of Daiwa Securities became the London branch of Daiwa's Dutch subsidiary, Daiwa Europe NV, with Koichi Kimura as the branch manager.

In the bond markets, the company was making good progress in the early 1970s. Buying of yen-denominated bonds in Europe developed in line with expectations of a strengthening of the yen, and in 1972 the company established a bond department in London to create a secondary market in yen-denominated bonds. The boom was disrupted by the 1973 oil crisis, but Daiwa's status as a market-maker was established, and its bond department was expanded by employing locally recruited bond dealers. The company's leadership in the Euroyen bond market, referred to in an earlier chapter, has been a highlight of its history in the London markets. The Euroyen bond market was opened in May 1977 with a European Investment Bank issue lead-managed by Daiwa followed by an IBRD issue, also lead-managed by Daiwa, later the same year.

Daiwa Europe Limited was established in 1980, displacing Daiwa Europe NV, and the company continued its move into the London markets thereafter, being granted membership of LIFFE in 1982 and the LIFFE Options market in 1985. The long-sought licence to operate a banking subsidiary in London was granted in 1987. For this purpose Daiwa Europe Finance had been established in 1986, the name being changed to Daiwa Europe Bank in 1988. In that same year Daiwa Securities, as already

described in a previous chapter, founded the Daiwa Anglo-Japanese Foundation, which has grown with generous funding into a major cultural and charitable institution. The then Chairman, Mr Chino, whose initiative was responsible for this endowment, was a notable Japanese broker and investment banker, and the only member of the Japanese brokerage community to receive an honorary knighthood in Britain. Daiwa remained effectively involved in charitable fund-raising, notably for the Save the Children Fund, with their London staff lending enthusiastic support. In 1991, the company bought a freehold site in Wood Street with planning permission, only to suffer the temporary frustration of having the existing building spot-listed. The sequel is described more fully in the chapter on property investment earlier in this book.

In recent years the company has continued to show condiderable leadership in the London based markets. Daiwa is now one of the world's leading underwriters in the sovereign and supranational debt markets, having led notable transactions such as those for the Kingdom of Denmark in DM, for the Republic of Italy in US$ and Yen, and more recently for the Asian Development Bank in US$. In the primary equity markets Daiwa developed a leadership role in the UK privatisation process. In 1987 it was the lead Japanese underwriter for the British Petroleum sale and in 1993 it was the only Japanese firm to form part of the global underwriting group for the third tranche of British Telecom.

Today, Daiwa Securities is one of the world's largest financial institutions, with over US $10 billion of capital, and a global operation covering 23 countries with 176 offices and around 11000 personnel. In London Daiwa Europe Limited with its Head Office in King William Street co-ordinates its European business, offering a full range of products. The King William Street office also

houses Daiwa Institute of Research (Europe), and commercial banking is provided by Daiwa (Europe) Bank plc in St Paul's Churchyard. The company was proud to celebrate its 30th anniversary in London in the City's Guildhall in 1994.

THE FUJI BANK[1]
(formerly the Yasuda Bank)

Zenjiro Yasuda, the bank's founder, opened a money exchange shop (Yasuda Shoten), in 1866, in Kobunacho. From an old *samurai* family, Yasuda was a self-made man of great discipline and fortitude, and a major public benefactor, as several distinctive buildings in Tokyo, including the Yasuda Hall of the University of Tokyo, still testify.

The early formative years of today's banking and financial system in Japan coincided with the development of the Yasuda Bank under the founder's leadership, during which some seventy other banks were acquired. In 1874 he was designated as the fiscal agent for the Ministry of Justice and for the Tochigi Prefectorial Government, entailing the depositing with him of large amounts of Treasury money, and in 1880 Yasuda Shoten was reorganised as the Yasuda Bank, with capital of Y 200,000, a Head Office in Tokyo and two local branches.

Over the succeeding twenty five years, the Yasuda Bank grew rapidly by rescuing or taking over many smaller banks and one large national bank, the 130th National Bank of Osaka. In 1921, Yasuda was murdered at the age of 82, but the bank which bore his name continued to expand at home, and in the early 1920s started to send middle management overseas for training. Growth was sharply accelerated in 1923 when, in consequence of its merger with ten regional banks, the Yasuda Bank became the largest bank in Japan as measured by capital deposits, loans and number of branches, with capital of Y150 million. It was one of the first Japanese banks to open an office in the City of London in the 1920s.

The financial panic of 1927, following on the failure of the Tokyo Watanake Bank, obliged even first-class banks to suspend business temporarily, and in the aftermath thirty

one were closed down. The subsequent enactment, in 1928, of the Bank Law designed to protect deposits engendered further consolidation within the Japanese banking world. Around that time, the Yasuda Bank, with others, pooled 10 million yen to take over the accounts of six failed banks and five other smaller banks still in operation; thus the Showa Bank was formed, to be absorbed into the Yasuda Bank in 1944.

After the Second World War, Yasuda and the other fourteen *zaibatsu* were dismantled, the name was prohibited, and control of the bank was removed from the family. By 1948, the former *zaibatsu* banks were essentially back on their feet, and on October 1 that year the Yasuda Bank was renamed the Fuji Bank, a name chosen by ballot by the bank's employees. The newly-named bank was still the leader in its field, as measured by total capital, deposits and loans, with capital of Y1350 million. In 1949 it had 189 offices and 7,899 *(sic)* employees.

The Fuji Bank was early in establishing in 1948 a Foreign Division to handle foreign exchange business and to promote trade, and in 1949 was designated, with others, as an authorised foreign exchange bank. Its business in the financing of trade bills was growing rapidly, and its corporate business was expanding; it was the 'commissioned' bank for thirty corporate bond issues in 1949/50 alone. The bank was also funding new plant and equipment and providing working capital for major corporate customers and trading houses; a high percentage of total loans went to the heavier end of the industrial spectrum, especially steel, chemicals, and machinery.

In 1952, the Japanese Ministry of Finance granted permission for the five major banks to reopen representative offices in London or New York. The Fuji Bank's first choice was London as the bank stated 'in view of the City's traditional pre-eminence as a financial centre'. In

August of that year, two staff were assigned to open the office, and, in doing so, sent the following commemorative telegram in English, to Tokyo: 'Humbly, but filled with hope, we opened our London office today'. The office, in Angel Court, was upgraded to a branch on 1st October 1952, with a staff of five Japanese and two British. In 1954, the Bank of England designated the Fuji Bank as an authorised bank. Offices followed in Calcutta and New York in 1953.

The boom in Japanese capital investment in the 1950s created a huge demand for investment funds. In Japan, the Fuji Bank's branch office network had been especially strong in the rural regions and faster growth was achieved by the more urban-based banks. Although Fuji remained the foremost in terms of total deposits, its share was being eroded, and in the late 1950s, new branches in Tokyo and a drive to attract new deposits enabled it to retain its leading position. At the same time, the bank's operations in the United States were being expanded, especially in New York, and its foreign exchange business grew rapidly.

The 1960s were a decade of fast-growing international trade following Japanese trade deregulation. Major Japanese companies were busy expanding abroad, and the Fuji Bank's Foreign Investment Department, established in 1962, was designed to render improved service to the bank's corporate customers in relation to foreign borrowings and overseas security offerings. The bank continued to grow in line with the expansion of Japan's economy, and especially overseas involvement. An expanded branch system at home and, an enhanced presence in the Asian economies in the late 1960s and early 1970s preceded the oil shock of 1973 and the subsequent slowing down of the Japanese economy; however, the Fuji Bank continued to build up its international network in the Middle East, the United States, Australia and Latin America. By 1980, the

bank had eight overseas branches and ten representative offices, together with eighteen subsidiaries and affiliates abroad engaged in financing, leasing, merchant banking, trust business, and securities.

In the early 1970s the Fuji Bank determined, as did other leading Japanese banks, to establish a securities arm in London in order to serve its customers' needs abroad. Activity in securities was forbidden for Japanese banks at home under domestic law, but the rise of the Eurobond markets and their substantial use for fund-raising by leading Japanese companies made such a move imperative if Fuji was to remain competitive.

The development of Fuji International Finance Ltd. in London has already been described in Chapter 2. Originally a joint venture with Kleinwort Benson, Fuji Kleinwort Benson Ltd was founded in 1973, with Mr Toru Hashimoto[2] as its first Japanese joint general manager. The strategic value of this subsidiary became significant in December that year, when the Japanese Government revised its policy and again allowed corporations to resume the issuance of bonds abroad, after a two-year prohibition. In 1977 the Fuji Bank bought out its London partner, and the finance company assumed its present title. Securities business was promoted vigorously through Fuji International Ltd. and through the Swiss subsidiary, Fuji Bank (Schweiz) AG in Zurich.

When, in 1975, the Tokyo capital market was reopened for foreign companies to issue yen notes and bonds and, in 1976, to raise medium and long-term yen-denominated loans, the Fuji Bank's business with foreign entities expanded still further. In 1979, the bank acted as manager of syndicated loans for 63 corporate clients in 26 countries, and by that year its annual volume of foreign exchange business had increased to $41 billion from $11 billion in 1973. By 1980, the Fuji Bank's Centenary Year, its total

deposits exceeded Y11,000,000 million, having doubled since 1974 and having risen 5 ½ -fold since 1968.

According to the bank's Annual Report for 1994 'net business profits' were $3.5 bn and the 'international gross profits' were larger than that of any other Japanese bank. It had 361 offices in Japan, and abroad mustered 19 subsidiaries, 19 branches or agencies and 23 representative offices. Thirty per cent of the bank's total income derived from overseas activities. Total assets, in 1994 were reported at $507 bn, the largest of any bank in the world, but more recently announced mergers between other Japanese leading banks will create even larger entities.

The Fuji Bank has stated that it expects to report its first pre-tax loss, in the region of Y440 bn ($4.37 bn) and the largest to date by a Japanese bank in the year ending March 1996. However, this loss includes a write-off of more than Y 800 bn, thereby eliminating most of its outstanding problem loans. This step is in line with the measures taken by the stronger banks to write-down non-performing loans rapidly and at a time when operating profits remain healthy.

INDUSTRIAL BANK OF JAPAN (IBJ)

In 1902, Japan's industrial development was beginning to develop rapidly. Corporations in key and nascent industries such as steel, machinery and shipping needed long-term funding, and the resultant demand for financial resources far exceeded the supply. Special legislation, in the shape of the Industrial Bank of Japan Law, established the bank as a semi-governmental institution in that year. Its mission was to respond to the funding needs of Japan's emerging industries by issuing debentures and accepting deposits, to attract foreign capital, and to assist in the development of securities markets.

In its early years, IBJ played a vital role in raising long-term funds from domestic and international sources. It helped in the placement of Japanese government bonds, and issued Industrial Bank of Japan debentures denominated in sterling in the London capital market. Between the start of World War I and the end of World War II, IBJ developed a pool of specialised knowledge, economic, commercial, and corporate, enabling it to make sound judgements as a supplier of credit. It helped to restructure Japan's shipping industry following World War I, established a dominant position in long-term lending and bond underwriting, and helped to provide relief for corporations in strategic industries during periods of economic difficulties.

Until 1948, when Article 65 of the Securities & Exchange Law went into effect, separating securities from banking, IBJ had an 80 per cent share of Japan's underwriting business. Thereafter, it was to become a private long-term credit bank, chartered under the Long-Term Credit Bank Law in 1952. Following the destruction of Japan's industrial base in World War II, the need for stable sources of long-term credit for basic industries was paramount at a time of only

slow savings growth; the efficient allocation of such funds was also an important requirement. IBJ's tasks were now to assist companies in heavy industry and the chemical sector in becoming internationally competitive and participating in infrastructure and regional development projects. Since the bank was independent of any of Japan's industrial groups, it was able to take objective decisions, and it came to play a leading role in mergers and acquisitions designed to create internationally viable corporate groups. The restructuring of the shipping, steel and automobile industries was much assisted by the bank's efforts. Its leading role in merging Yahata Steel and Fuji Steel in 1970 to create Nippon Steel Corporation, the world's largest ferrous metals producer, was a good example of its effectiveness. In the wake of the stock market slump in the mid-1960s, it played a key part in the restructuring of the securities industry, and in restoring the soundness of the stock market.

In the early 1970s, IBJ began to build an international network of branches and subsidiaries, As Japanese overseas direct investment grew, so the bank needed to strengthen its overseas capabilities in advance of its customers' needs. In 1971, the bank already had a representative office in London, but, in that year it was upgraded to branch status, and moved its offices from Mincing Lane in the City, to King Street. In 1973, it moved again, to Bucklersbury House where it was joined in 1975 by IBJ International, its wholly owned securities subsidiary, and IBJ Leasing in 1987. As total staff grew (from 76 in 1986 to 223 in 1991), the bank had to find larger premises. In December 1991, the then Lord Mayor of London, Sir Brian Jenkins unveiled a plaque to commemorate completion of the redevelopment of Bracken House, the UK's first major post-war building to be listed, and IBJ were able to occupy it in March 1992. In 1991 it had made a notable contribution to the success of the Japan Festival in London

by co-sponsoring (with British Telecom) an exhibition at the Royal Academy of the works of the famous Japanese artist, Katsushika Hokusai.

Today, IBJ has twelve overseas branches, twenty representative offices and nineteen subsidiaries worldwide, 90 per cent of the leading 200 Japanese companies are among its clientele, and it holds a major share of equipment loans for industrial companies. Deregulation in Japan allowed it to establish a domestic securities subsidiary, IBJ Securities Co, Ltd in 1993. Bond issuance has remained a major activity, and its investment banking activities in London, Frankfurt and Zurich place it among the leading international investment banks conducting business in Europe. IBJ International plc in London ranks particularly high in terms of the volume and sophistication of bond and equity-linked underwriting.

MITSUI & Co[3]

Of all the Japanese trading companies, Mitsui was the first to venture abroad. The celebration, in 1980, of the centenary of their first establishment in London was a reminder of the Company's perceived status as Japan's first commercial ambassador.

The Mitsui General Trading Company (*soga shosha*) was one of many founded in the late 19th century after the reopening of Japan's ports, following the Meiji restoration. The company had its origins in the *zaibatsu* established by the last Mitsui *samurai* in 1650. It was officially founded in Tokyo in 1876, and the London Branch was opened only four years later at 1, Crosby Square in the City. The original task of this office was to market rice; the Japanese Government had appointed Mitsui as marketing agents for rice sales to Europe and Mitsui sent a young American entrepreneur, who had already acted on their behalf elsewhere, to London to open an agency for this purpose. The American, R.W. Irwin, was successful. He also engaged in exporting woollen blankets and other items from Britain to his principals in Japan. His agency was duly upgraded to the status of a branch office. Motoaki Sasase was the first Japanese to arrive, in 1880, as its branch manager.

It was unfortunate that, in the same year, the rice trade was virtually halted as a sharp fall in the Japanese economy and spiralling inflation persuaded the Japanese Government to restrict rice exports. Early losses in this area in London were soon made good, however, and Sasase went on to develop trade in a wide range of products, especially textile machinery. For the next fifty years, through Mitsui's agency, large quantities of textile manufacturing plant and ancillary equipment such as boilers were exported to Japan and elsewhere in the East by such companies as Courtaulds,

Platt Brothers, and Babcock & Wilcox. This particular trade was instrumental in establishing Japan's major world position as a textile manufacture, a significant example of 'technology transfer'.

Mitsui's London branch was also active in importing from Japan products which were becoming increasingly popular as British appreciation of Japanese culture grew. China, earthenware and silk figured strongly in this trade which, however, remained relatively small in relation to British exports to Japan. After the First World War, Britain failed to regain its strength in overseas trading markets and lost ground to the United States and Germany. Mitsui's exports from Britain fell from £26.5 million to £14 million between 1924 and 1926 alone, yet the balance of trade remained strongly in Britain's favour, with woollen and worsted piece goods, iron, steel and heavy machinery as the major items. Mitsui at that time was importing a wide variety of manufactured goods from toys to silk clothing, but these were mainly for domestic rather than industrial use, and their overall value was not significant. The branch ceased to operate in 1942, but resumed operations in 1952 when the Japan-US Treaty paved the way for a resumption of Mitsui's overseas business. By 1960 the branch had regained its former complement of staff which had been 120 at the close of business in 1942.

Although the great trading houses, such as Mitsui & Co, had enjoyed in days gone by a foreign capital financing function, their activities had been greatly restricted by government regulation; In the 1960s, however, liberalisation and deregulation allowed them greater freedom, and the ability to handle major plant exports and overseas construction development projects, together with an expanded role in the domestic distribution system. The banks were happy to supply them with funds, leaving the financing of smaller companies, de facto, in their hands. Their financial

and foreign exchange functions could now be improved and enlarged. Rapid expansion and increased profitability were now possible and as Japan's exports grew, so this opportunity was grasped. As an example, following the long strike by American steelworkers in 1961, the United States became the leading export market for Japanese steel, largely thanks to Mitsui & Co's foresight in establishing a marketing network across the country. Ship export business proved to be another growth area, particularly bulk carriers.

By 1970, Mitsui & Co was handling about 10 per cent of Japan's exports and 12 per cent of its imports, the latter being mainly raw materials, and over the next few years began to undertake investment activities aimed at directly realising earnings from overseas investment. The oil crisis in 1973-4 severely affected profits, and Mitsui & Co's heavy concentration on chemicals, iron and steel and non-ferrous metals made it particularly vulnerable. However, increased business in export of plant helped recovery, and the added role played in the 1970s by the company's overseas subsidiaries enhanced the company's fund-raising capability.

Mitsui & Co, Europe Ltd was established in the City of London in 1974, its function being that of the management company supervising all its offices in Europe, and co-ordinating activities. In the mid 1970s the company established a joint venture with British Leyland (Japan-Leyland) for the import and marketing of B.L. products in Japan. The company plays a leading role in trade between Britain and Japan, especially in steel, chemicals, textiles, foodstuffs and motor cycles for the British market, and exporting machinery, non-ferrous metals, whisky, foodstuffs and textiles to Japan. The London Office also engages actively in third country transactions.

Location in the City is of prime importance to management, since its function includes raising capital independently for large-scale projects and joint ventures. The company has an active recruitment programme for British graduates. There has been a marked change in Mitsui's trading pattern since 1980; offshore business has become increasingly prominent, leading to increased autonomy for offices such as London, The latter was converted into a UK company in 1987, Mitsui & Co UK plc. Today, Mitsui's London business with headquarters in Old Bailey, remains the second largest, after New York, of Mitsui's overseas subsidiaries.

THE HOUSE OF NOMURA[4]

The Nomura Securities Co. Ltd. was established in Osaka in 1925, but owes its origin to Tokushichi Nomura I. He had set up Nomura Shoten as long ago as 1872, engaging in money-changing, and became a broker in the new Osaka Securities Exchange in 1878. Tokushichi Nomura II, born in 1878, in the year of the founding of the Tokyo Stock Exchange was to become one of Japan's greatest stockmarket operators. Nomura Securities successfully weathered the panics and pitfalls of the late 1920's. It had, from its inception, an international outlook, and was, indeed the first Japanese securities firm to open an overseas office, in 1927, in New York. By 1942, Nomura, with a market share of 19 per cent was the leading securities house in Japan, and the Nomura enterprise had become the tenth largest *zaibatsu* in Japan. In November 1945, the Nomura Group's assets were frozen along with those of the 14 other biggest *zaibatsu*, by the government, on the orders of the Occupation GHQ. Nomura Securities Co, as a member company of the group had to make a fresh start, with new management. In 1949, the Tokyo, Osaka and Nagoya Stock Exchanges reopened. 'Normality' had been restored.

In the same year the President of the company, Mr Okumura, announced his intention to pursue the internationalisation of Nomura's business and an Overseas Section was created. In 1951 regulation regarding foreign residents acquisition of shares in the secondary market was relaxed. Transactions on behalf of non-Japanese became a significant feature of the Japanese stock market. By 1953, Nomura had re-established an office in New York. Throughout the expansion of the Japanese economy in the 1950s, Nomura retained its position as the largest securities firm, and when, in 1961, there was a partial relaxation of

restrictions on overseas capital transactions, Nomura was well-placed to take a lead role. Expansion followed in the United States, with the issuance, in New York of American Depositary Receipt issues of Japanese stocks. Nomura was selected as the co-manager of the first such issue, for Sony Corporation – which proved to be a stunning success and led to a greatly increased international acceptance of Japanese securities. Nomura had reorganised its corporate structure in preparation for liberalisation of trade and foreign exchange regulations. As European interest grew in investing in Japanese securities (in November 1961 the London brokers Vickers da Costa established its 'Anglo-Japanese Investment Trust') so Nomura, along with other Japanese brokers turned increasing attention to Europe.

The Interest Equalisation Bill approved by President Kennedy in mid-summer 1963 brought Nomura's business – selling Japanese stocks to Americans – to a halt. This event brought a dramatic shift of emphasis to London; and in March 1964, Nomura opened a representative office in London in Gresham Street. From its inception this office covered a wide range of activities: the building of relationships with European banks, underwriters and institutional investors, providing information on Japanese securities, and information – gathering on financial trends in Europe's capital markets. The first priority was, however, to sell Japanese stocks to European stockbrokers. Nomura's first London manager was Keisuke Egashira. He was to become a highly respected and successful member of the City's financial community. He developed close friendships with Edmund Rothschild and Sigmund Warburg. Nomura's financial position was, by now, very strong, as was that of the other three big Japanese securities houses.[5]

In 1969 Nomura was the first Japanese house to be admitted as member of a foreign stock exchange – as a member of the Boston Stock Exchange. Membership of

the Pacific Stock Exchange was to follow and, in due course, the New York Stock Exchange. In 1970, Nomura joined Mitsui, Sanwa and Dai-Ichi Kangyo in the establishment of the Associated Japanese Bank (International) Ltd. in London, a traditional consortium bank concentrating on syndicated loans. The increased two-way flow of capital, between Japanese and overseas markets in the 1970s as a result of progressive deregulation and liberalisation, led to a further expansion of Nomura's international activities and organisation. By the early 1970s, Nomura in London had seven Japanese and eleven British staff. In 1972, Nomura reorganised its London and Amsterdam branches as one subsidiary, Nomura Europe N.V. Nomura now became involved in a full range of banking activities in Europe, as well as securities brokerage. Through Nomura Europe N.V. it handled medium and long term loans, accepted deposits in European currencies and handled foreign exchange dealings. In 1973, as a result of the first 'oil shock', Nomura became busily engaged in handling Middle Eastern accounts in London.

Nomura's overseas business was, in 1978, put under the control of Masanori Ito, and in 1980 Nomura moved its European headquarters from Amsterdam to London. Under his leadership the early 1980s were a time of sustained expansion abroad for Nomura, highlighted by a major recruitment drive for high-grade college graduates overseas. Nomura International began to hire British graduates several years ahead of its Japanese rivals. Many of these graduates were sent to Tokyo for training. In 1982, twenty eight graduates from Britain and the United States were flown to Tokyo, where they were put under control of Hitoshi Tonomura,[6] a general manager. It is recorded that some complained about the Japanese breakfast diet of fish or rice with a raw egg on top. In due course, Tonomura allowed them to have cornflakes. In the period

1982-5 Nomura doubled the numbers of local nationals employed in its overseas offices to over 700. Significantly, London was chosen in 1981 as the administrative centre for Nomura International's European operations. Nomura's regulation and strengths were acknowledged in London notably by its selection in 1985, as joint lead manager for the British Telecom Privatisation offer, along with Morgan Stanley and Kleinwort Benson. In the same year Nomura lead-managed the first Euroyen bond issue by a foreign private corporation (Dow Chemical) and played the same role in the first issue by a Japanese company of Euroyen convertible bonds.

In 1986 Nomura opened a licensed deposit-taking subsidiary in London (Nomura International Finance plc). This move into commercial banking in London after lengthy negotiations to obtain a UK licence followed upon Nomura Europe N.V.'s full banking licence granted in the Netherlands in 1972 (although full banking services had not been developed in the Amsterdam office). This was part of Nomura's diversification strategy in the 1980s, consistent with its aim of being in the top group of giant financial 'supermarkets' by the turn of the century alongside the large global banks. It was felt that a banking base, together with foreign exchange capabilities, funding expertise and credit analysis, was essential for this purpose. Restricted from engaging in banking activities in Tokyo, Nomura considered that London had clear advantages as the best location for such endeavours.[7] As the cockpit of international finance, London was deemed to be unrivalled in Europe, because of its vastly superior infrastructure of banking, insurance and commodity markets. Nomura also took into account London's traditional welcome to foreign institutions, its sensible regulatory climate, its pool of skilled labour and the benefit of the English language – the language of world finance.

By 1987, Nomura, with a net profit of more than $2 billion had not only become the most profitable company in Japan, but had outstripped American financial leaders such as Citibank, Merrill Lynch and American Express to become, at that time the most profitable financial institution in the world. In the same year Nomura Securities donated $2.5 million for the construction of a new gallery for the Tate Gallery in London, and was complimented by Prime Minister Margaret Thatcher for doing so. In the world stock market crash in October that year, Nomura, with about 18 per cent of the daily volume in the Tokyo Stock Exchange, led the other members of the 'Big Four' in successfully stabilising the Tokyo market by persuading its clients to buy stocks heavily.

By 1990, Nomura's overall strengths were formidable. It had five million customers in Japan, and its net worth exceeded $17 billion - more than the combined profits of Merrill Lynch, Morgan Stanley, Paine Webber, Salomon Brothers and Bear Stearns in America. It had over $10.7 billion in shareholder's equity and accounted for 15 per cent of all traded volume on the Tokyo Stock Exchange. In April 1994 Nomura announced that its office in the City of London already its European administrative headquarters, was also to be its European operational headquarters, and that its fifteen offices on the continent of Europe were, in future, to report to London, instead of Tokyo.

Nomura's London-based bank, now known as Nomura Bank International plc. has continued to grow. By the end of the financial year in March 1995, its balance sheet reached £3.47 billion, and, in contrast to a disappointing year immediately earlier, the bank was profitable. With the Capital Adequacy Directive due to become effective in early 1996, the bank has invested strongly in risk management and management information systems. Nomura now has a network of European companies with

banking licences – in Amsterdam, Brussels, Luxembourg and Zurich, and as the process of financial integration continues throughout Europe, the Nomura Group as a whole is strongly placed to play a major role in these markets.

THE SAKURA BANK
(formerly Mitsui Taiyo Kobe Bank)

The Sakura Bank developed its present structure through several mergers and acquisitions of other banks, each proud of its history. Of these, The Mitsui Bank was the oldest and best known. The book 'The Mitsui Bank', published in 1976 to mark the Bank's centenary compares its historical origins to that of the Bank of England founded in 1694, for in 1683 Hachirobei Takatoshi Mitsui opened a money exchange shop in Edo (Tokyo).

The Mitsui Bank, as established in 1876, was the first private commercial bank in Japan, continuing the exchange shops of its predecessor, and developing offices in the provinces to serve the agricultural community, to handle public funds, government fiscal affairs and, later, banking operations on behalf of the Bank of Japan after the latter began operations in 1882. It also provided financial support for Mitsui Bussan (the Mitsui trading company), and began to use its funds for investment and financing: It was initially capitalised – as was the Mitsui Bussan – at twenty million yen; it went on to develop its trust and corporate debenture underwriting business. The man who has been described as the father of the Mitsui Bank was Rizaemon Monomura, the Deputy President, who had died in 1877. He is credited with having done more than any other man to bring Mitsui into the modern age. One of Japan's leading experts in monetary affairs, he had successfully planned with the Mitsui family and negotiated with the government the bank's organisation and establishment.

The bank was well established before the onset of the Sino-Japanese War in the early 1890s, accounting at the time for 40 per cent of the total deposits of all regular banks. However, the rapid increase in the number of banks

coincident with the strong advance in the economy after that war, led to its market share declining to about 6 per cent by the turn of the century. In 1897, it still had the largest sum of deposits and loans of the five largest banks (the others being the Dai-Ichi, Mitsubishi, Sumitomo and Yasuda Banks) and still held this position in 1907.

One of the first foreign correspondent agreements by a regular Japanese bank with a foreign bank was made in 1906 between the Mitsui Bank and Barclays Bank in London. To secure that contract, the Mitsui Bank had to present national bonds as collateral and to make an interest-free deposit of £10,000 against which Barclays would accommodate up to £100,000.[8] The bank's foreign exchange business expanded rapidly after 1915, because of increased export activity, and it began to underwrite foreign bonds in 1916, thus taking its first steps towards investing overseas. The growth in foreign exchange transactions led to the stationing of liaison representatives in London and New York. The first public offer for sale of Mitsui Bank stock was made in 1919. It was quickly sold out, bringing in 2,000 public shareholders.

In the natural disasters and financial upheavals of the 1920s, the bank continued to operate successfully, providing relief loans to major commercial businesses and substantially increasing its deposits. In common with the other four large Japanese banks, Mitsui benefited, in the banking panic of 1927, from the flight to quality by depositors. Overseas development began with a branch in Shanghai in 1917, a New York agency in 1922, and a London branch in 1924. The Mitsui Bank was to become prominent in the overseas flotation of foreign currency bonds for Japanese public utility companies, largely subscribed for in New York, but also, in 1928 and 1931 in the case of Nippon Electric Power and Tokyo Electric Light, with sterling tranches placed through London. By

the end of the 1930s, the Mitsui Bank was the leader, among Japanese banks and trust companies, in the amount of domestic bonds underwritten.

When Britain abandoned the Gold Standard in September 1931, the Mitsui Bank was faced with problems regarding the settlement of its foreign exchange contracts between Britain and the United States, and as a result, was obliged to make major purchases of US dollars against yen. This, together with earlier dollar purchases aroused public and media criticism in Japan regarding the activities of Japanese financial institutions abroad, and Mitsui incurred much unpopularity as a result. There were some large withdrawals of deposits by large corporations, and Mitsui's hitherto top ranking among the five largest Japanese banks was lost.

The advent of World War II led to the closure of the London branch in October 1940, and of the New York and Bombay branches in December 1941. In 1942, after the start of the Pacific War, the Japanese Government took control of the monetary system and, as part of a general policy, promoted the merger of the Mitsui Bank and the Dai-Ichi Bank in 1943 – the new bank being named the Teikoku Bank, Japan's largest with deposits of 5,600 million yen. It was, in turn, soon to merge with the Jugo Bank in 1944, bringing total deposits to 7 billion yen.

With the compulsory dissolution of the *zaibatsu* during the occupation, following the end of the Pacific War, their assets were frozen and the Mitsui *zaibatsu* were split apart. The Teikoku Bank plan, which it was obliged to file for the disposal of its credits, was approved in 1948, and under the severe conditions imposed, shareholders and depositors suffered heavily, as was the case for the other leading Japanese banks.

Although banks had not been officially listed in the Elimination of Concentration Law, the Teikoku Bank's

reorganisation plan submitted to the Government and approved by the S.C.A.P. included the formal dissolution of the bank, and the ending of the link with the former Dai-Ichi Bank, which became separately constituted. The 'new', slimmed-down Teikoku Bank was not allowed to use the old *zaibatsu* name Mitsui, had lost half its branch network and half of its funds. The 'new' bank's shareholders no longer contained members of the Mitsui family.

As the economy recovered after the start of the Korean War, the Teikoku Bank found itself substantially overlent, and this 'overloan' situation had to be stabilised and then resolved. This process was slow at first, but as the bank's volume of foreign exchange transactions increased in the early 1950s, so it began to re-establish its overseas correspondent branch network – and its overseas offices. In 1952, it re-opened its London Branch, and in January 1 1954, it renamed itself The Mitsui Bank. The period of high economic growth 1958-63, with GNP growth averaging over 14 per cent per annum, brought far reaching economic and social reforms, and a huge increase in demand for capital investment, with emphasis on the new technologies. This had the effect of intensifying the 'overloan' situation, which had earlier been the result of war-related dissipation of accumulated capital.[9]

The rate of deposit growth was inadequate to match the demand for funds. The Mitsui Bank had difficulties, as others did, in expanding its operations at this stage but under the leadership of President Masuo Yanagi, the Bank in 1962 adopted a long-term strategy designed to re-establish deposit and loan growth. Technical innovation contributed further and, in 1965, the Bank was the first in Japan to adopt an on-line, real-time computer system; the stage was set for a closer relationship with the general public. Loans for consumer durables became a growth area

for the Bank, and housing loans for the public followed after 1964. In that year, total deposits reached 1 trillion yen. The lifting of certain restrictions on the financial sector in 1968 led to a new wave of bank mergers and reorganisation, and the Mitsui Bank merged in that year with the Toto Bank, thus expanding its branch system and the links with the general public. Business as a 'peoples' bank continued to grow in the 1970s; by 1971 total deposits reached 2 trillion yen, and 3 trillion yen in 1972.

The decade of the 1970s saw further growth in Mitsui Bank's international network. It participated with Nomura Securities, the Sanwa Bank, the Dai-Ichi Bank and the Nippon Kangyo Bank in the establishment of the Associated Japanese Bank (International) Ltd. in London in December 1970. The main business of this consortium bank was to raise funds in the Eurodollar market, and to operate these funds for long-term corporate financing, and for securities-related and other purposes. Further expansion followed for the Mitsui Bank in Europe, and in Brazil. Hambro-Mitsui Ltd. was established in 1973 as a joint venture with Hambros Bank. The aim was to conduct business across a wide international spectrum, including securities underwriting, finance mediation and consultancy services. Further expansion established the Mitsui Bank via joint ventures in Lebanon, Hong Kong, Indonesia, Philippines, Zaire, Colombia, Malaysia and the Gulf. In 1975 it formed a link with Thomas Cook & Sons in issuing yen travellers' cheques.

By 1976, its Centennial Year, the Mitsui Bank numbered 12,000 employees, 150 domestic branches, and numerous joint-venture undertakings. The Bank's capital totalled 55 billion yen, and total deposits 4 trillion yen. Further growth in the 1980s, both domestic and overseas was followed in 1990 by a merger with the Taiyo Kobe Bank, changing

the name to the Mitsui Taiyo Kobe Bank, thus creating the largest network of any Japanese city bank, with assets of 61 billion yen. The Taiyo Kobe Bank, with almost the same size of assets as The Mitsui Bank, was a major international bank, having been established by the merger in 1973 between The Bank of Kobe and The Taiyo Bank (established in 1936 and 1940). The creation of the Mitsui Taiyo Kobe Bank, the second largest bank in the world, was a major topic of interest in the financial world at that time. The Mitsui Taiyo Kobe Bank has, in recent years played a significant part in major Project Financing. In 1991, it was lead manager in the £795 million natural gas power generating plant project in Teeside, England – then the largest private sector project of its kind. Through London and Hong Kong it has assumed a leading role in international aircraft financing. It has also strengthened its derivatives team in London, and established its mergers and acquisitions team there.

April 1 1992 was the date for the change of name to the Sakura Bank Ltd., and in that year Sakura Finance International Ltd., based in London, was the leading Japanese bank in lead-managing in the Euromarket underwriting league. Further deregulation of the financial system in Japan in 1992 opened the way for Sakura Bank's international subsidiaries (including London-based Sakura Finance International Ltd.) to assume lead-management positions for issues of Japanese equities. In the same year, Sakura Finance was lead-manager for the first Eurobond yen issue – for 35 billion yen – for the European Bank for Reconstruction and Development in London. The London Branch was again noteworthy in the Project Management field in 1993 when, working with the Bank's headquarters in Tokyo, it was the lead manager in the Pakistan Hub River Power Project and the Qatar LNG Project.

The Sakura Bank's London Branch continues to be a leader in the Japanese financial community in the City of London.

THE SUMITOMO BANK

The Sumitomo Bank was an early participant in the City and its 67, Bishopsgate branch opened in 1918. The bank's part of the Sumitomo Group was established as a private bank in Japan 1895: it opened letters of credit through Lloyds Bank as early as 1903, and had correspondent relationships. Like other Japanese banks it had been looking seriously at overseas markets following the expansion of Japanese exports during the First World War. The London branch was established to allow Japanese customers access to the sterling market – the dominant international currency. As a full branch, with about twenty staff, it offered normal banking facilities and correspondent banking, as well as export/import and foreign exchange facilities. The bank records show that it took several weeks for its staff to travel from Japan; there were no aircraft or telex facilities, only telegrams, code books, and inefficient telephones. The branch continued at much the same level of staff during the 1920s and 1930s, but was closed when Japan entered the Second World War. The Bank of England found employment for redundant local staff, and all the records and ledgers of the London Branch were deposited in the vaults of Lloyds Bank where they remained in safe keeping.

In 1953, the Sumitomo Bank reopened in London with a representative office at 4, Copthall Court, and in 1956 a full branch was opened with a staff of twelve, of which half were Japanese. By 1953, fifteen staff were employed at its new offices in Bucklersbury House. With Japan in the 1950s still much preoccupied with rebuilding its domestic economy, the Bank's business in London was very much trade-related, and linked with access to the money markets. By the 1960s, however the Bank's activities were reflecting the underlying pattern of activity of its Japanese customers.

In mid-decade, the Sumitomo Bank took the decision to internationalise. It sent staff at all levels abroad – not only to its branches, but to colleges and language schools. Thus, the Bank equipped itself for the skills necessary for an upsurge in international business.

Growth continued for the Sumitomo Bank. In 1970 there were thirty five staff at new offices at 5, Moorgate, on the corner of Gresham Street and opposite the Bank of England. Although the core business was still related to Japanese customers, the branch had been an active and early participant in the syndicated loans market deriving from the Eurodollar market which had emerged in the 1960s. At the same time relationships were being established in the UK corporate sector via short term uncommitted lines, and then long-term loans. The volume of foreign exchange activity was also growing rapidly. In 1978 there were seventy three staff at Sumitomo's present site at 11, Queen Victoria Street. The bank's expansion in London in the 1970s was in keeping with the acceleration in the Japanese economy after the 1973 oil crisis, and again in 1979.

Today the bank employs 260, in the City excluding subsidiaries elsewhere in London and a representative office in Birmingham. The Sumitomo Bank's securities business in London is conducted by its subsidiary, Sumitomo Finance International. The Bank's view is that although the US dollar is the key currency for world trade, both New York and Tokyo are inherently domestic markets whereas London has an inherent internationality. London's international position derives from the size and importance of its markets, the availability of a skilled workforce, the availability of ancillary professional services, openness towards foreigners, a 'straightforward' regulatory approach, and the openness of the UK and Euromarkets operating in London.

THE BANK OF TOKYO
formerly The Yokohama Specie Bank –
Japan's first International bank

The Yokohama Specie Bank was the first Japanese bank to go abroad – and London was the natural venue. Founded in 1880 as a government bank whose mission was to serve as the centre of Japan's foreign finance, it became an important instrument of the Japanese Government's drive towards international expansion.[10] When Matsukata became Finance Minister in 1881, he supported the Yokohama Specie Bank in its competition with the western banks in Yokohama to finance domestic Japanese exports. In that same year an officer of the bank joined the Japanese legation in Bishopsgate to open a representative office which, upgraded to a branch office in 1884, displaced the liquidated Oriental Bank as the conduit in London for the Japanese government's business; the 84 Bishopsgate office became an independent branch of the Bank with a Mr Tokuda as Manager. It was now the sole monetary agent for the Government of Japan and responsible for payments to service the foreign loans which had been raised in London. It developed strong contacts with the City including Lloyds Bank, its main business being the discounting of foreign bills of exchange for Japanese exports. The export trade was supported by the Japanese government by lending paper currency to the Specie Bank which repaid the government in foreign currency, especially sterling, the leading international currency.

The Japanese monetary crisis in 1890, occasioned by the failure of the rice harvest the previous year, led to further expansion in London, through the establishment there of an exchange fund of just over £1 million. Soon, all the gold business of the bank was allocated to London. When the Japanese government insisted that the huge Chinese

indemnity be paid in London, it requested the Bank of England, in 1895, to open an account for the Specie Bank to receive the first instalment. Thus, the first major banking link was forged between Britain and Japan. The receipt was signed in London by the Imperial Envoy Extraordinary and the Chief Cashier of the Bank of England. Of the total sum of £38 million, £33 million was paid in London over the next three years. In 1898, the final instalment of £11 million was the largest cheque ever drawn, up to that time, by the Bank of England.[11]

The indemnity money was remitted to Japan, partly in bills of exchange, and partly in gold specie. Nakai Yoshigusu, who had become manager of the Specie Bank in 1891, became a well-known and highly respected figure in London. It was he who had been the main negotiator for the complex process of the Chinese indemnity payment. In 1896 he contributed an article to the *Bankers Magazine* the first Japanese to do so. In 1899, he became a director of the Specie Bank, and was awarded the Fifth Order of Merit by the Meiji Emperor, uniquely for a banker who was neither a soldier nor a government official. *The Bankers Magazine*, in its obituary of Nakai in 1903 commented 'he had to meet with all the difficulties which beset the path of a bank working in a city to which it was a stranger. When the office was first opened, it was treated as of little account by other Eastern exchange banks, but, by dints of persevering labours and judicious management of its chief, the Yokohama Specie Bank worked its way into a place of prominence among these institutions having connections with Oriental countries'.

By 1903, the foundations had indeed been laid for the successful raising of loans in London for the financing of the war with Russia of 1904-5, and, in that year the Japanese Government informally ordered the Y.S.B. to raise funds in the bank's name. In May 1904, the

Y.S.B., in conjunction with Parr's Bank and Hongkong and Shanghai Bank as co-underwriters, successfully led an offering of £10 million Imperial Japanese Government Sterling Bonds, which was heavily oversubscribed. This event added substantially to the Y.S.B.'s credibility in Japan and London, and led on to a succession of such issues in London, in all of which the Y.S.B. played a substantial part. By 1910, nearly £200 million had been raised, through London by the Japanese Government. The bank remained active in London after World War I and as part of the 'Enlarged London Group' underwrote the £60 million Japan Government Loan of 1924, a large proportion of which was placed in New York, as were several subsequent issues in the 1920s. The last such loan in that period was raised in London in 1930.

After World War II, the Bank of Tokyo was designed to replace the Yokohama Specie Bank, as a private bank. With many of its predecessor's executive officers, it was to lead Japan's foreign exchange business and to finance foreign trade.[12] In 1952, it reopened its London office, the first large Japanese financial institution to do so since the war. The Manager was Mr Yamazaki, and the Deputy Manager, later to be the Manager was Mr Ichiro Matsudaira. The latter was the son of Matsudaira Tsuneo, former Ambassador in London (1929-35) and later Imperial Chamberlain in Tokyo. His sister married Prince Chichibu, younger brother of the Showa Emperor. The Princess Chichibu was to become President of the Japan-British Society in Tokyo and, sadly, died in 1995.

The re-opening of an office in London was to allow the bank to act as fiscal agent for the re-starting of payment of principal and interest on the outstanding Japanese Government foreign loans. The early activities included trade finance, lending to Japanese trading and manufacturing companies, raising sterling deposits in the London money

markets, and lending to the Bank of Tokyo's other offices. The Foreign Exchange Bank Law of 1954 recognised the Bank of Tokyo as Japan's specialised foreign trade bank. It was to focus, therefore on international operations and helping Japanese companies who wished to expand abroad. In 1970, when the Ministry of Finance liberalised the foreign exchange market, further expansion was to follow, and in the late 1970s and early 1980s, the bank lent heavily to Latin American governments and, accordingly, suffered as a result of the debt crisis in South America.

The year 1981 was the 100th anniversary of the Bank's London office, and the celebrations included a Centenary Reception at the Mansion House, the Lord Mayor receiving the guests, and a visit by the Lord Mayor Sir Ronald Gardner-Thorpe to the Bank of Tokyo's offices at 20-24 Moorgate, to be greeted by the then President, Mr Y. Kashiwagi. The Bank of Tokyo's new premises at Finsbury Circus House were officially opened in March 1992 by the then Lord Mayor, Sir Brian Jenkins who cut the ceremonial tape in the presence of H.E. Hiroshi Kitamura, the Ambassador of Japan and Mr Eddie George the then Deputy Governor, but now Governor, of the Bank of England. The President of Bank of Tokyo Ltd., Mr T. Takagaki, was present to receive the Lord Mayor.

Today, the London office has a broadened spread of activities, including Treasury, mergers & acquisitions, corporate banking, merchant banking, securities business and investment management. Currently, expansion is taking place in securitisation, derivatives, electronic banking and business with other financial institutions, The City of London office, which employs about 490 people out of a UK total of 500 and a total in Europe of 1,300, houses the Resident Managing Director for Europe,[13] the European Credit Office and the East European Office. The announcement in 1995 that the bank is to merge with

Mitsubishi Bank in April 1996 to be named the Bank of Tokyo-Mitsubishi will create, in size of assets, the world's largest bank to date.

THE BANK OF YOKOHAMA

The Bank of Yokohama, which was originally called Yokohama Koushin (credit) Bank, was established on 16th December 1920, with a capital of Y 1 million. Its aim was to serve the banking needs of individuals and of companies in Kanagawa Prefecture, to the South of Tokyo.

Following the great Kanto earthquake on September 1 1923 which caused enormous damage in both Tokyo and Yokohama, the Government declared a one-month moratorium on debt repayment and allowed banks to discount 'earthquake bills'. In the 53rd Diet in 1927, the opposition pressed for publication of the amounts of 'earthquake bills' held by individual banks. The Government resisted this demand for fear that it would trigger a run on the banks, but was unsuccessful. Some banks, such as the Watanabe Bank in Tokyo, were soon forced to close and there was a heavy run on The Souda Bank in Yokohama. The ultimate outcome was a merger of many banks and in 1927 the Yokohama Koushin Bank merged with the Souda Bank. In the following year a further merger was achieved with Daini Bank, formerly called Yokohama Daini National Bank, and established as far back as 1874. Further small mergers and acquisitions took place in the late 1920s and 1930s and the Yokohama Koushin Bank grew substantially in the Kanagawa Prefecture. Meanwhile, in 1941, the Japanese Government announced the policy of 'one bank for one Prefecture' and as a result the six remaining banks in the Kanagawa Prefecture were merged and formed a commercial bank, then still known as the Yokohama Koushin Bank.

In 1957, when its capital was Y 700 million and its deposits some Y 50 billion, the bank changed its name to the Bank of Yokohama. Four years later, in 1961, it was listed on the Tokyo Stock Exchange. Benefiting from the

region's rapid and dynamic economic growth, the Bank of Yokohama greatly expanded its business and its territory to the West and South of Tokyo and became Japan's leading regional bank in the 1970s. In the free world, it ranked 48th in terms of deposits in 1994. The bank's international business has developed in response to its clients' growing international expansion.

By 1973 the bank decided to establish its first overseas presence and opened the London Representative Office, which two years later achieved branch status, engaging in lending, deposits, and treasury business. Mr J.F. Hill, from the Royal Bank of Scotland, was appointed the first General Manager of the branch. After several major financial transactions, including a Certificate of Deposit issued in 1977, and a Floating Rate issue in the following year, the branch moved to 40 Basinghall Street, and currently has some thirty four employees. The New York office was opened in 1976 and became a branch in 1979.

The 1980s was the most significant decade of development for international operations. Branches, representative offices and security subsidiaries were established in Europe, the Americas and Asia, totalling sixteen overseas offices overall.

A unique opportunity arose in 1989 when the Bank of Yokohama made a bid for the London merchant bank Guinness Mahon. Guinness Mahon had originally been established in Dublin in 1836. The bank initially acquired a 65 per cent stake and 10 per cent was distributed to the Bank of Yokohama's commercial clients in Japan. Initially, Guinness Mahon kept its listing on the London Stock Exchange. Concurrently, the Bank of Yokohama with Guinness Mahon Holdings set up a leasing company, Guinness Yokohama Leasing, in London. However, two years later, affected by the severe downturn in the UK economy, the Bank decided to acquire the

whole of Guinness Mahon Holdings and this resulted in its relinquishing its London quotation. A new management team was introduced under the Chief Executive Officer, David Potter, who was joined later by David Atterton as Chairman. The Bank of Yokohama seconded senior executives to assist Guinness Mahon, including Mr Asai, Mr Shinozaki and Mr Ozawa, who have made an outstanding contribution to Guinness Mahon's growth.

The implications of this acquisition are many. The Bank of Yokohama is the only Japanese bank which owns an independent merchant banking operation in London. It has invested significant capital in Guinness Mahon Holdings since the acquisition. It is benefiting through various cross-border transactions generated by Guinness Mahon Holdings and Guinness Mahon Holding's ability to serve the Bank of Yokohama's clients' needs in the European market. This activity has been particularly marked in corporate finance, asset management, capital markets, development capital and media business. A further significant benefit to the Bank of Yokohama, as the deregulation process continues in Japan, will be the knowledge transfer in fund management, the securities business, and capital markets, to its benefit and to that of its clients. GMH Group now comprises the merchant bank, Guinness Mahon & Co. Limited, the fund management company, Guinness Mahon Global Asset Management, Henderson Crosthwaite Limited (one of the ten largest client stockbroking firms in the United Kingdom), Henderson Crosthwaite Institutional Brokers, and Guinness Mahon Development Capital.

Notes and References

Chapter One

1. Later Butterfield & Swire who moved to London in 1870.
2. Now part of Guardian Royal Exchange plc.
3. Sir Hugh Cortazzi, 'Biographical Portrait of Sir Harry Parkes' in *Britain and Japan: Biographical Portraits*, Ian Nish, Japan Library, 1994.
4. Sir Fred Warner, *Anglo-Japanese Financial Relations*, p.24, Blackwell 1991.
5. Richard Roberts, *Schroders - Merchants & Bankers*, pp.70-3, Macmillan, 1992.
6. Sir Fred Warner, *Anglo-Japanese Financial Relations*, p.29, Blackwell, 1991.
7. Ibid., p. 33.
8. Toshio Suzuki, *Japanese Government Loan Issues on the London Capital Markets*, The Athlone Press, 1994.
9. Parr's Bank was merged after World War I into the Westminster Bank now part of the NatWest Bank.
10. David Kynaston, *The City of London Vol. II - Golden Years 1890-1914*, pp. 350, 390-4, 412-13, Chatto & Windus, 1995.
11. Now known as the Foreign and Colonial Investment Trust and, founded in 1868, the City of London's oldest surviving investment trust.
12. Ian Nish (ed), *Britain and Japan: Biographical Portraits*, Japan

Library, 1994.
13 Sir Marcus Samuel's Diary as Lord Mayor, Guildhall Library.
14 Sir Hugh Cortazzi, 'The Japan Society. a Hundred Year History' from *Britain and Japan 1859-1991*, Sir Hugh Cortazzi and Gordon Daniels, Routledge, 1991.
15 Marie Conte-Helm, 'Armstrong's, Vickers and Japan' in Ian Nish (ed.), *Britain and Japan: Biographical Portraits*, Japan Library, 1994
16 F. Hadland Davies, *Japan*, Jack, 1916.
17 Sir Fred Warner, *Anglo-Japanese Financial Relations*, pp. 65,66, Blackwell, 1991.

Chapter Two

1 Sir Fred Warner, *Anglo-Japanese Financial Relations*, p.91, Blackwell, 1991.
2 Richard Roberts, *Schroders, Merchants and Bankers*, pp. 229, 230, Macmillan, 1992.
3 Ibid, p 201.
4 Mitsui Bank, *The First Hundred Years*, 1976.
5 Richard Roberts, *Schroders, Merchants and Bankers*, p 335, Macmillan, 1992.
6 Sir Fred Warner, *Anglo-Japanese Financial Relations*, p 124, Blackwell, 1991.
7 Now the Japanese Chamber of Commerce and Industry in the United Kingdom. Initial membership was a mere 34 companies mainly financial, trading and shipping. To reflect Japanese industrial and commercial investment outside London, the name was changed in 1974. In March 1955 there were 414 member companies, 184 of which were located in London.
8 The Canon Camera Euro-dollar Convertible issue, lead-managed by Loeb, Rhoades & Co (later to be absorbed into Shearson Lehman American Express, now part of Lehman Brothers), was switched from New York to London at the last minute.
9 Now Chairman, Globe International Group in New York.

Notes and References 165

10 *The First Hundred Years*, Mitsui Bank; 1976.

Chapter Three

1 Robert Pringle and Elizabeth Hennessy, *Japanese Investment in Britain - Banking and Financial Services* a report prepared by Graham Bannock & Partners for the Anglo-Japanese Economic Institute and Gresham College, 1991.
2 Telerate Bank Register.
3 R.A. Brealey and E. Kaplanis 'The Growth and Structure of International Banking', *City Research Project Report XI*, Corporation of London, 1994. See also Harold Rose, 'International Banking Developments and London's Position as a Banking Centre', *City Research Project Report G*, Corporation of London, 1994.
4 Sir Fred Warner, *Anglo-Japanese Financial Relations*, p. 145, Blackwell, 1991.
5 Ibid, pp. 157-9.
6 The first being Mr Hitoshi Ishihara of Yamaichi International (Europe) Ltd.
7 Andreas Prindl, 'Starting a bank in London - the Nomura experience' in *Marketing Financial Services* David B. Zenoff, Ballinger Publishing, 1989.
8 A few inner-London boroughs became notoriously lacking in diligence in their foreign currency borrowing against municipal assets.
9 Andreas Prindl 'Starting a Bank in London - the Nomura experience', *Marketing Financial Services*, David D. Zenoff, Ballinger Publishing, 1989
10 Eugene R. Dattel. *The Sun that never rose*, p.208, Probus Publishing, 1994.
11 Sir Fred Warner, *Anglo Japanese Financial Relations*, p.163, 1991.

Chapter Four

1 Robert Pringle and Elizabeth Hennessy, *Japanese Investment*

in Britain - *Banking and Financial Services*, a report prepared by Graham Bannock & Partners for the Anglo-Japanese Economic Institute and Gresham College, 1991.
2 'The Role of Japanese Financial Institutions in Europe', speech by Rafael Kirchstein, Director, Nomura Bank (Switzerland) Ltd., in March 1990.
3 White Paper on World and Japanese Trade, December 1993.
4 'The City and Inward Investment', Report by London Economics, sponsored by The Corporation of London, September 1995.
5 Former Head of the European Delegation in Tokyo, Adviser to Panasonic Europe and Director-General for External Affairs of the European Commission.

Chapter Five

1 Source: Bank of Japan London Representative Office
2 Nomura Research Institute, Europe.
3 London Stock Exchange Fact Book 1994.
4 The Home Secretary being responsible for the Metropolitan Police, who cover the rest of London and not the City.
5 Mr Nagaoka
6 Robert Pringle; 'The Future of Japan's financial and other services in Britain', Japanese Investment in Britain, The Global Context ,Anglo-Japanese Economic Institute, 1995.

Chapter Six

1 The London Stock Exchange Fact Book, 1995
2 *The Tokio Marine Fire Insurance*, Tokio Marine, p.6, 1980.
3 *Sumitomo Marine & Fire Insurance*, Sumitomo Marine, p.12, 1993.
4 Archives, Guardian Royal Exchange plc.
5 *The Tokio Marine Fire Insurance*, Tokio Marine, p.8, 1980.
6 Ibid, p.41.
7 Ibid, pp.49-50.

Notes and References

8 Ibid, p.53.
9 Ibid, pp.53-4.
10 David Keir, *The Bowring Story*, Bodley Head, pp.294-5, 1962.
11 *Sumitomo Marine & Fire Insurance*, Sumitomo Marine, p.46-9, 1993.
12 Mitsui Marine & Fire, *Building Protection*, Mitsui Marine, p.34, 1994.
13 *Sumitomo Marine & Fire Insurance*, Sumitomo Marine, p.69, 1993.
14 Ibid, p.102.
15 *The Tokio Marine Fire Insurance*, Tokio Marine, p.148, 1980.
16 Ibid, p.153.
17 Bernard Ross Collins, *The History of Sedgwick Collins*, London, p.63, 1969.
18 Mitsui Marine & Fire, *Building Protection*, Mitsui Marine, pp.126-9, 1994.
19 Ibid, p.156.
20 Ibid, p.170.
21 *Sumitomo Marine & Fire Insurance*, Sumitomo Marine, p.172, 1993.
22 Ibid, p.193.
23 Bruce Farthing, *International Shipping*, Lloyds of London Press, p 97, 1993.
24 Ibid, p 100.

Ten Brief Histories

1 *Fuji Bank 1880-1980*, Fuji Bank, 1980.
2 Now President of Fuji Bank and Chairman of the Federation of Bankers Associations in Japan.
3 *Mitsui & Co Ltd. A Century in Britain*, Mitsui, 1983.
4 *Beyond the Ivied Mountain, Nomura 1872-1985*. The Nomura Securities Co Ltd, 1985.
5 Nomura's capital, which totalled Y 50 million in 1948, Y 200 million in 1949, Y 500 million in 1952, Y 1 billion in 1953, Y 2 billion in 1956, Y 4 billion in

1959, Y 8 billion in 1961 had reached Y 12 billion by 1964.
6 Mr Tonomura was later to become head of Nomura's European Organisation
7 Andreas Prindl, chapter entitled 'Starting a Bank in London, The Nomura Experience', *Marketing Financial Services*, ed. by David B. Zenoff, Ballinger Publishing, 1989.
8 Mitsui Bank, *A History of the First 100 Years*, p.80, 1976.
9 Ibid, p.141.
10 Norio Tamaki 'The Yokohama Specie Bank in London 1881-1903' in Ian Nish (ed.) *Britain and Japan: Biographical Portraits*, Japan Society, 1994.
11 The Bankers Magazine 1898, p 863.
12 Sir Fred Warner, *Anglo-Japanese Financial Relations*, p. 121, Blackwell, 1991.
13 Currently Mr Tadashi Kurachi.

Bibliography

Brealey, R.A. and Kaplanis E., *The Growth and Structure of International Banking*, City Research Project Subject Report XI, Corporation of London, 1994.
────── *The City and Inward Investment: Revitalising the UK Economy*, Report by London Economics, Corporation of London, 1995.
────── *Fuji Bank 1880-1980*, Fuji Bank, 1980.

Conte-Helm, Marie, 'Armstrong's Vickers and Japan', in *Britain & Japan, Biographical Portraits*, Ian Nish, Japan Library, 1994.
Cortazzi, Sir Hugh, 'Sir Harry Parkes, 1828-1885' in *Britain & Japan: Biographical Portraits*, Ian Nish, Japan Library, 1994.
────── 'The Japan Society: A Hundred-Year History', in *Britain and Japan 1859-1991*, Sir Hugh Cortazzi and Gordon Daniels, Routledge, 1991.

Farthing, Bruce, *International Shipping*, Lloyds of London Press, 1993.

Hadland Davis, F., *Japan*, T.C. & E.C. Jack Limited, 1916.

Keir, Andrew, *The Bowring Story*, Bodley Head, 1962.
Kynaston, David, *The City of London Vol II – Golden Years 1890-1914*, Chatto & Windus, 1995.
────── *The 100 Year History of Mitsui & Co Ltd. 1876-1976*, Mitsui & Co, 1976.

──── *Mitsui Bank, A History of the First 100 Years*, Mitsui Bank, 1976.
──── *Building Protection; The Story of Mitsui Marine & Fire Insurance 1918-1993*, Mitsui Marine, 1994.
──── *Beyond the Ivied Mountain 1872-1985*, Nomura Securities, 1985.

Prindl, Dr Andreas, 'Starting a Bank in London – the Nomura Experience' in *Marketing Financial Services*, David. B. Zenoff, Ballinger Publishing, 1989.

Pringle, Robert and Hennessy, Elizabeth, *Japanese Investment in Britain – Banking and Financial Services*, report prepared by Graham Bannock & Partners for the Anglo-Japanese Economic Institute and Gresham College, 1991.

Roberts, Richard, *Schroders, Merchants and Bankers*, Macmillan, 1992.

Rose, Harold, *International Banking Developments and London's Position as a Banking Centre*, City Research Project Subject Report XII, Corporation of London, 1994.

Ross Collins, Bernard, *The History of Sedgwick Collins & Co*, Sedgwick Collins, 1969.
──── *Sumitomo Marine & Fire Insurance, The First Century 1893-1993*, Sumitomo Marine, 1993.

Suzuki, Toshio, *Japanese Government Loans in the London Capital Markets*, Athlone Press, 1994.

Tamaki, Norio, 'The Yokohama Specie Bank in London 1881-1903' in *Britain & Japan: Biographical Portraits*, Ian Nish, Japan Library, 1994.
──── *The Tokio Marine & Fire Insurance, The First Century*, Tokio Marine, 1980.

Warner, Sir Fred, *Anglo-Japanese Financial Relations*, Blackwell, 1991.
──── *White Paper on World and Japanese Trade*, 1993.

Index

A
Abe International, 67
Aiwa, 60
Akiko restaurant, 36
Alliance Assurance, 103
American Depositary Receipts (ADR's), 25, 39
American Express, 144
Angel Court, 130
Anglo-Japanese Bank, 15
Anglo-Japanese Commercial Treaty 1962, 24
Anglo-Japanese Cultural Agreement 1960, 24
Anglo-Japanese Economic Institute, 74
Anglo-Japanese Naval Alliance, 8, 12
Anglo-Nippon Trust, 27
Anti-Comintern Pact of 1936, 20
Aoki Viscount, 11
Arisugawa Prince: entertained at Mansion House, 11
Armstrong Whitworth & Co, 12, 15
Asahi Bank, 99
Asahi Life Insurance, 63, 68
Asahi Life Investment Europe Ltd, 62
Asahi Shimbun, 118
Asahi Urban Development, 69

Associated Japanese Bank, 28, 142, 150
Atlas Assurance, 106
Atterton Dr David, 162
Austin Friars, 67

B
Baltic Exchange, 82, 112
Bank of England, 146; City of Tokyo loan support refused 1923, 18; deposits for Japanese foreign exchange, 14; draws largest cheque 1898, 156; finds employment for redundant local staff in WWII, 153; objects to financing for Japanese imports 1947, 21; special account opened for Japan 1895, 7, 156; sterling accounts allowed for Japanese, 23
Bank for International Settlements (BIS), 44, 77, 90
Bank of Japan, 88, 94; aims in London in 1950s, 22; Bank of England agreement 1956, 23; London office opens 1905, 10; London office reestablished 1951, 21; Mr Matsushima briefed on security by Lord Mayor 1993, 86
Bankers' Magazine The, 35, 156
Banking Bureau, 3
Barclays Bank, 147

Baring Brothers, 18; lead issuer 1902 loan, 8; placing Japanese issues abroad, 8
Basinghall Street, 69, 161
Bearsted Lord. *See* Samuel
Big Bang, 42, 43, 73
Birchin Lane, 22
Birmingham, 154
Birmingham University, 117
Bishopsgate, 19, 66, 69, 79, 82, 83, 85, 153, 155
Bonner Act, 113
Bonner Amendments, 113
Bowring CT & Co, 105, 106
Bracken House, 67
British Bankers Association (BBA), 94
British Depositary Receipts, 25
British Invisible Exports Council (BIEC) later British Invisibles, 47
British Leyland (Japan-Leyland), 138
British Telecom (BT), 41
Broadgate, 70
Bucklersbury House, 153

C
Cameron Mr Alan senior partner Panmure Gordon, 18
Cannon Street, 36
Canon Camera, 26
Capel James, 27; friendly ties with Japanese, 37
Capital Outflow Prevention Act of 1932, 20
Carr WI, 27
Cassidy Mr Michael Chairman Policy and Resources Committee, 86
Cazenove & Co, 27; brokers for Taisho Marine London issue 1964, 109
Chartered Mercantile Bank, 3
Chichibu Prince, 157
Chichibu Princess, 157
China, 20; indemnity paid to Japan, 7; trade with Britain, 2
Chino Mr Yoshitoki (Chairman Daiwa Securities), 116, 126
Chiswell Street, 124
Chiyoda Bank. *See* Mitsubishi Bank
Chiyoda Life Insurance Co, 62, 63
Chiyoda Property & Casualty Insurance, 111
Chuo Trust & Banking Company Ltd, 99
Citibank, 144
City Engineer, 85
City of London: direct investment in UK encouraged, 56; early Japanese visitors, 2; Europe's financial epicentre, 44, 51; first Japanese banking presence, 6; foreign bills use of, 6; HM Emperor Hirohito praises, 29; Japan's credit rating, 7, 18; MoF Visitors Briefed, 21; restoration of Japanese presence, 21
City of London Police, 85
City Research Project, 35
City University, 117
Clarke Mr Kenneth Home Secretary, 83
Clay Mr John, 26
Clifford Chance Solicitors, 64
Commercial Code of 1899, 5
Commercial Continental Bank, 28
Commercial Union Assurance, 103, 106, 111
Committee of European Shipowners (CES), 113
Consortium banks. *See* joint venture banks
Consultative Shipping Group of Governments, 114
Copthall Court, 22, 153
Corporation of London, 65, 87; dedication to business community, 57; honouring Japanese, 115; hospitality to Japan

Index

Society and Prince Fushimi, 12; Prince Yorihito welcomed, 16; Reception for Japan Festival, 115; security action 1993, 85
Cortazzi Sir Hugh, 115
Council of European and Japanese National Shipowners Associations (CENSA), 113
Crosby Square, 136
Crown Prince of Japan HIH, 115

D

Daichi Uno, 62
Daido Life Insurance, 62
Dai-Ichi Bank: shares in Associated Japanese Bank 1970, 28
Dai-Ichi Kangyo Bank (DKB), 95, 99; brief history, 122, 123
Dai-Ichi Life Insurance, 62, 63
Daiichi Mutual Fire & Marine, 108
Dai-Ichi National Bank, 103
Daiwa Anglo-Japanese Foundation, 116, 126
Daiwa Bank, 89, 99
Daiwa Europe Ltd, 95, 99
Daiwa Foundation Japan House, 116
Daiwa Securities, 69, 117, 127; brief history, 124; Eurobond leadership, 40; Euroyen leadership, 40; Foundation established 1988, 116; London Stock Exchange membership 1986, 96; office opens in Queen Street, 36; property investment, 65
Deloitte & Touche, 112
Department of Trade and Industry (DTI), 45, 94
Derby, 52
Deutsche Bank, 90
Dillon Read, 25
Dimsdale Sir Joseph Bt. *See* Lord Mayor of London
Direct Investment from Japan, 51, 61
Douglas-Whyte Mr Lex, 108
Dresdner Bank, 90
Dublin, 161
Dunlop, 15

E

Economist The, 73, 89
Edo Bay, 1
Egashira Mr Keisuke, 141
EIE, 68
Elimination of Concentration Law, 148
Emmott Mr Bill, 73
Emperor of Japan HM: Hirohito visits London as Crown Prince 1921, 16
Erlanger Mr Emile, 4
Ernst and Young, 112
Eurodollar market, 24, 26, 40; convertible bonds, 25; Eurobonds, 25, 42, 50
European Depositary Receipts, 26
European Monetary Institute (EMI), 55
Euroyen, 40, 41, 44, 125, 143
Exchange controls (UK), 39, 43
Exchange Rate Mechanism, 75
Export-Import Bank of Japan, 117

F

Fanmakers Worshipful Company of: exhibit at Japan-British Exhibition 1910, 12
Federal Reserve Bank, 32
Federation of Bankers: associations with Japan, 28
Fenchurch Street, 68
Fielding Sir Leslie speech, 60
Finsbury Circus, 63, 66, 116
Fire Insurance Union, 104
First Boston, 25
Fleet Street, 64, 65
Fleming Robert & Co, 27; Fleming Japan Fund, 27
Flemish, 57

Floating Rate Notes, 44
Foreign and Colonial Investment Trust, 8, 37
Foreign Banks & Securities Association, 95
Foreign Exchange Bank Law of 1954, 158
Foreign Exchange Central Board, 21
Foreign Exchange Market (FOREX): London's share still rising, 91
Foreign Office, 8
Foreman Mr, 5
France, 53, 56
Frankfurt, 55, 77, 91, 124, 135
Fuji Bank, 99, 132. See Yasuda Bank; brief history, 128; joint venture with Kleinwort, 28; reopens City office 1952, 22
Fuji International Finance, 29, 99
Fuji Kleinwort Benson Ltd, 131
Fukuda Miss Haruko speeches, 37, 38, 42, 80, 91
Fuso Marine and Fire Insurance, 106

G
Gardner-Thorpe Sir Ronald. See Lord Mayor of London
General Accident Insurance, 106
General Agreement on Tariffs and Trade (G.A.T.T), 24
George Mr.Eddie The Governor Bank of England, 158
Germany, 20, 24, 50, 53, 56; War declared by Japan 1914, 13
Glover Mr Thomas Blake, 2
Gold Standard, 9, 19, 148
Goldman Sachs, 64
Goodhart Mr Charles, 75
Governor of the Bank of England. See Bank of England
Grand Metropolitan plc, 67
Great Britain Sasakawa Foundation, 116
Gresham Street, 36, 141

Guardian Royal Exchange, 65, 68; agreement with Sumitomo Marine & Fire Insurance, 110
Guildhall, 16; Daiwa Securities celebrates 30th anniversary, 127; HM The Emperor Hirohito's speech, 29; security advice, 85
Guinness Mahon, 73, 161
Gyohten Mr Toyoo, 76
Gyosei College, 117

H
Hambro-Mitsui Ltd, 28, 150
Hambros Bank, 150; arranges London issue for Taisho Marine 1964, 109; joint venture with Mitsui Bank, 28
Hammerson Group, 63
Hamomoto Mr M, 95
Hansa, 57
Hartley, Cooper & Co, 106
Hashimoto Mr Toru, 28, 131
Hayashi Viscount, 12
Hazama Corporation, 67
Healey & Baker, 91
Henderson Crosthwaite Limited, 162
Hendon, 36
Hill Mr JF, 161
Hiraiwa Mr President of the Keidanren, 87
Hirasawa Mr Sadaaki B, 75
Hirohito HIH The Crown Prince (later HM The Emperor): visits London 1921, 16
Hitachi, 26, 52, 60
HM The Emperor of Japan: State Visit as Emperor, 29
Hokusai Mr Katsushika, 135
Honda, 52
Hongkong and Shanghai Banking Corporation, 66, 67, 157; early lending to Japanese business, 5; financing Japanese imports, 21; helps Japanese banks in 1950s,

Index

23; Japan Government loans, 18; Japan Government loans, 7
Hosokawa Mr Morihiro Prime Minister of Japan, 87
Huguenots, 57
Hull Insurers Union, 107

I

IBJ International, 96, 99
IMO, 112
Imperial Fire Insurance, 103
Inagaki Mr Masao, 96
Industrial Bank of Japan (IBJ), 67, 95, 99, 135; announcement of 1993 City expansion, 78; brief history, 133
ING Group, 90
Insurance (non-life), 103
Interest Equalisation Bill, 141
interest-rate swaps, 44
International Chamber of Shipping (ICS), 113
International Monetary Fund (IMF), 24
International Pacific Corporation of Australia, 27
International Stock Exchange. *See* London Stock Exchange
Irwin Mr RW, 136
Ishihara Mr Hitoshi, 96
Italy, 20, 53, 56
Ito Mr Masanori, 142
Ito Prince, 2
Itoh C, 26, 65, 67
Itoh Mr K: President of Sumitomo Marine & Fire Insurance, 108
Ivory & Sime., 62

J

Japan: Customs Loan 1870, 4; Government loan 1897, 7; Offshore Market, 32; War declared on Germany 1914, 13
Japan Bank International, 28
Japan Development Bank, 117
Japan Festival, 115, 134
Japan Herald, 103
Japan Society: celebrates Centenary 1991, 115; Japan-British Exhibition 1910, 12
Japan Working Group. *See* BIEC
Japanese Chamber of Commerce and Industry, 83
Japanese Chamber of Commerce and Industry in London, 93
Japanese Chamber of Commerce and Industry in the United Kingdom, 93
Japanese Shipowners Association (JSA), 113
Jardine Fleming, 47
Jardine Matheson, 13
Jenkins Sir Brian. *See* Lord Mayor of London
JCCI, 93
JETRO, 52
JIJI Press, 55
Joint venture banks, 28, 122
JVC, 60

K

Kagami Mr Kengichi, 104
Kajima Corporation, 66
Kaku Mr T, 83
Kanagawa Prefecture, 160
Kane Mr Koichi, 96
Kaneko Mr Masashi, 96
Kankaku (Europe), 99
Kankaku Securities, 96
Kansai, 104
Kanto earthquake, 18, 106, 160
Kashiwagi Mr Y, 158
Kato Kagaku, 69
Kawamura Mr M, 97
Kawasaki Steel, 25
Keidanren, 87, 115
Kelly Mr Owen Commisioner City of London Police, 86
Kennedy Administration, 25, 141
Keswick Mr William, 2

Kiaochau, 13
Kimura Mr Koichi, 125
King Professor Mervyn, 76
King Street, 134
King William Street, 68, 126
Kiowa Bank, 28
Kipling Rudyard, 118
Kitamura HE Hiroshi, 1, 53, 58, 158
Kleinwort Benson: global lead-manager BT offer, 42; joint venture with Fuji Bank, 28
Kobayashi, 3
Kobe, 103, 104
Kobe Insurance Company, 105, 106
Kokusai Europe, 99
Komatsu, 26
Korean War, 22, 39, 149
Kowa, 69
KPMG, 112
Kubota Mr Isao, 76
Kuhn Loeb, 25
Kumagai Gumi, 63, 66, 82
Kyoto, 59; visit of Lord Mayor 1994, 87
Kyushu, 2

L
Lay Mr Horatio Nelson, 4
League of Nations, 20
Little Britain, 64
Livery Companies. *See* Fanmakers
Lloyds Bank, 153, 155
Lloyds of London, 111, 112
Lloyds Register of Shipping, 112
Lombard Street, 7, 67
London & Lancashire Insurance, 103, 104
London Business School, 117
London Group, 10
London International Financial Futures Exchange (LIFFE), 81, 97
London Investment Bankers Association (LIBA), 95
London Joint Stock Bank, 6
London School of Economics, 74
London Stock Exchange: Japanese participation. *See* the Stock Exchange and International Stock Exchange; Japanese seats in 1988. *See* the Stock Exchange and International Stock Exchange; Japanese share turnover, 78
Long Term Credit Bank of Japan, 83, 99
Lord Mayor of London: Dimsdale 1901, 12; Gardner-Thorpe, 115, 158; Japan Society involvement, 12; Jenkins, 115, 134, 158; Newall, 55, 59, 86, 87; Reception for HIH Prince Yorihito, 16; Samuel, 9, 11; Spratt, 115; Treloar, 12; Tyler 1894, 11
Luxembourg, 27

M
M.I.M. Britannia, 62
Manchuria, 20
Mansion House: Bank of Tokyo Centenary Reception, 115, 158; briefings for Japanese bankers 1994, 86; Japan Society entertained 1903, 11; Japan-British Exhibition launched 1910, 12; Japanese children invited, 116; Mansion House Fund to relieve Japanese famine, 11; Prince Arisugawa entertained 1905, 11
Marshall Plan, 23, 25
Masuyama Mr Seiichi, 74
Matsudaira Mr H, 95
Matsudaira Mr Ichiro, 157
Matsudaira Mr Tsuneo, 157
Matsukata Prince Masayoshi, 9, 155; and Schroders, 5
Matsushima Mr Masuyuki. *See* Bank of Japan

Index

Matsushita, 59, 68, 78
McCooey Mr Christopher, 118
Meiji Fire Insurance, 104, 108
Meiji Government: appoints YSB as London agent 1884, 6; encourages British visitors, 2; finances exporters, 6; first railway, 4; overseas trade, 6
Meiji Life Insurance Co, 62, 64
Merchants Marine Insurance, 103
Merrill Lynch, 27, 144
Merseyside, 57
Mikasa the flagship, 13
Million Trading Company, 99
Minamimato Mr S, 95
Mincing Lane, 134
Ministry of Finance, 23, 75, 88; liberalises foreign exchange market, 158; limits specie held in Britain, 16; team visits London, 21
Mitsubishi Bank, 95, 99, 159; joins London consortium, 28; opens City office 1920, 19; plans merger with Bank of Tokyo, 88; reopens City office 1952, 22
Mitsubishi Chemicals, 40
Mitsubishi Company, 67, 103
Mitsubishi Electric, 60
Mitsubishi Finance International, 90, 99
Mitsubishi Marine Insurance, 106, 108
Mitsubishi Real Estate, 63, 65, 66
Mitsubishi Trust, 67, 99
Mitsui & Co, 139; becomes agent for British Insurance Companies, 104; brief history, 136; establishes London Office, 6; forms insurance company in 1918, 106
Mitsui Bank. *See* Sakura Bank; Associated Japanese Bank, 28; first office in London, 19; joint venture with Hambros, 28; reopens in the City 1952, 22

Mitsui Construction Co, 69
Mitsui Fudosan, 66
Mitsui Life Insurance, 62
Mitsui Marine & Fire Insurance, 106
Mitsui Mr Hachirobei Takatoshi, 146
Mitsui Real Estate, 63
Mitsui Trust & Banking Co, 99
Monomura Mr Rizaemon, 146
Moorgate, 154, 158
Morgan Grenfell & Co, 18, 28
Morgan JP, 64
Morgan Stanley, 25, 42
Mori Mr Kengo Financial Commissioner, 18
Morse Sir Jeremy, 94
Murata Mr Shozo, 105

N
Nagasaki, 2, 13
Nagatomi Mr Yuichiro, 75
Nakai Mr Yoshiguso, 156
Nakazawa Mr Nobuo, 96
Naruse Mr Tomonori, 76, 94
Nathan & Rosselli, 37
National Westminster Bank: helps Japanese banks reestablish in London in 1950s, 23
NEC, 60
Nelson Admiral Lord: Japanese sailors visit tomb at St Paul's, 12
Netherlands, 56
New Japan Securities, 37, 96, 99
New York, 16, 18, 25, 86, 91
New York Stock Exchange (NYSE), 39
Newall Sir Paul. *See* Lord Mayor of London
NHK, 117
Nikko (Europe), 91, 96, 99
Nikko Securities, 117; employees in 1994, 82; leadership in Eurobond issues 1989, 51; membership London Stock Exchange 1986, 96;

177

opens first office in Cannon Street, 36
Nippon Credit Bank, 99
Nippon Electric Power, 19, 147
Nippon Fire and Marine Insurance, 105
Nippon Fund, 27
Nippon Life Insurance, 62, 63, 64, 68
Nippon Steel Corporation, 134
Nissan, 52
Nissan Fire & Marine Insurance, 110
Nisshin Fire & Marine Insurance, 111
Nissho Iwai, 68
NKK Securities, 37
Nobuyoshi Mr Sakumo, 106, 107
Nomura International Finance plc, 43, 96, 99; selects London for banking operations, 42
Nomura Mr Tokushichi I, 140
Nomura Mr Tokushichi II, 140
Nomura Securities, 116, 145; associated Japanese Banks, 27; brief history, 140; cut-backs in 1995, 89; employees in 1994, 82; European operating headquarters, 80; Euroyen issues, 40; membership London Stock Exchange 1986, 96; office in St. Martin-le-Grand, 66; opens office in Gresham street, 36; Pacific Seaboard Fund, 27
Nomura Shoten: early establishment, 5
Norwich Union Insurance Group, 70, 106
Nozu Mr Takashi: Chairman of Gyosei Board of Trustees, 117
NYK Lines (Europe) Ltd, 113

O
Oguso Mr H, 108
Ohbayashi, 67
Okasan International (Europe), 102

Okumura Mr, 140
Okura, 6
Old Bailey, 68, 139
Ono Mr Yosuki Bank of Tokyo, 22
Oriental Banking Corporation, 5, 6
Orion Bank, 28
Orix, 70
Osaka, 59, 104; visit of Lord Mayor 1994, 87
Osaka Bank. *See* Sumitomo Bank
Osaka Marine and Fire Insurance, 105
OSK, 105

P
Pacific Seaboard Fund, 27
Panasonic, 52
Panmure Gordon & Co: Broker to Japanese issues, 8; Friendly ties with Japanese, 37; Japan Government Eurodollar issue 1963, 25; Japan Government loan 1924, 18
Paris, 25, 91
Parker Sir Peter, 115
Parkes Sir Harry, 2
Parr's Bank: leads 1899 loan consortium, 7; role in Government loan 1904, 9, 157
Paternoster Square, 65
Pearl Harbour, 20
Perry Commodore, 1
Philpot Lane, 36
Phoenix Fire Assurance, 103, 104
Potter Mr David, 162
Prime Minister. *See* Hosokawa; Takeshita Mr, 115
Prindl Dr Andreas, 42, 72, 117
Privatisation, 41, 81, 126, 143
Provisional IRA, 82
Prudential Assurance Co, 64

Q
Queen Street, 36, 124
Queen Victoria Street, 154

Index

Quick, 66

R
Revelstoke Lord, 8
Rome, 25
Rothschild Mr Edmund, 141
Rothschild N M & Co: declines role 1902, 8; helps Japanese banks reestablish, 23; international connections, 10; Japanese friendships, 37; Pacific Seaboard Fund, 27; placing Japanese issues abroad, 8; role in Japan loan 1924, 18
Royal Arsenal The, 13
Royal Bank of Scotland, 161
Royal Exchange Assurance. *See* Guardian Royal Exchange
Royal Navy, 12
Runcorn, 52
Russo-Japanese War, 5, 9, 104, 156

S
Saba Mr Shoichi, 115
Sakura Bank, 99, 152. *See also* Mitsui Bank; brief history, 146
Samuel: *See* Lord Mayor of London, 11
Samurai Bonds, 39
San Francisco Treaty of 1951, 22
Sanwa Bank, 69, 102; Associated Japanese Bank, 28; Commercial Continental Bank, 28; joint venture with Barings, 28; opens London office, 23; suffers from bomb 1992, 82
Sanwa Futures, 102
Sanwa International, 102
Sanyo, 60
Sasakawa Mr Ryoichi, 116
Sasaki brothers, 3
Sasase Mr Motoaki, 136
Save and Prosper Group. *See* Robert Fleming & Co
Schroder Mr Helmut, 22

Schroders: Bank of Japan, 21; co-manages Japanese Eurodollar issue, 25; financing Japanese imports 1950, 21; helps Japanese Banks in 1950s, 23; Japanese vase presented, 5; launches first Japanese Government loan 1870, 4; Nippon Electric placement, 19; orchids impress Japanese, 22; role in Japan loan 1924, 18
Sedgwick Collins & Co, 105, 107, 108
Seibu Saison, 67
Shand Mr Allan: manager Parr's Bank, 7
Sharp, 60
Shimizu, 66
Shipping, 112
Shirayama Corp, 68
Showa Ota & Co, 112
Sitow Mr, 98
Sony, 52, 59, 141
Spratt Sir Greville. *See* Lord Mayor of London
St Mary Axe, 82
St Paul's Cathedral, 12
St. Martin's-le-Grand, 66
Sterling Area, 23
Stevenson Mr Edward, 106
Sumitomo Bank, 22, 89, 102, 154; becomes Osaka Bank, 21; brief history, 153; joins London consortium, 28; opens branch in City 1918, 19; reopens office 1953, 22
Sumitomo Corp, 69
Sumitomo Finance International, 90, 102
Sumitomo Life Insurance, 62, 63, 68
Sumitomo Marine & Fire Insurance, 108, 109
Sumitomo Metal, 25
Sun Alliance Insurance, 111
Sun Fire Office, 104
Sun Insurance, 106

Sunderland, 52
Suntory and Toyota International Centre (STICERD), 116
Swiss Bank, 62, 90
Switzerland, 24

T
Taguchi Mr, 3
Taisei Corporation, 63, 66
Taisei Fire & Marine Insurance, 111
Taisho Marine & Fire Insurance, 106, 108, 109, 111
Takagaki Mr T, 158
Takahashi Korekiyo: early training from Alan Shand, 3; visits London, 9
Takahashi Mr Korekiyo, 7
Takai Mr Kunihiko, 94
Takeda, 26
Takenaka, 67
Takenaka Mr H, 95
Tamaki Mr Nori, 9
Tamura Mr Tatsuya, 94
Tanaka Mr President of Tokio Marine & Fire 1950, 108
Tate Gallery, 116, 144
TDK, 67
Teijin, 26
Teikoku Bank. *See* Sakura Bank
Thatcher, Mrs Margaret (later Baroness), 39, 45, 144
Thomas Cook & Sons, 150
Tobe Mr, 79
Togo Admiral, 13
Tohmatsu, 111
Tokai Bank, 102; forms joint venture with Kiowa Bank and Morgan Grenfell, 28; funds Professorship of Finance, 117
Tokai Bank Europe, 96, 102
Tokio Marine & Fire Insurance, 106, 108, 109, 111; buys 150 Leadenhall Street, 69; foundation of, 103
Tokuda Mr, 155

Tokyo: Lord Mayor's visit 1994, 86
Tokyo Bank of, 94, 99, 159. *See also* Yokohama Specie Bank; brief history, 155; Lord Mayor opens new premises 1992, 116; Mansion House Centenary Reception, 115; Mr Ono visits Schroders, 22; office in City reopens 1952, 22; participation in LIFFE, 97; plans merger with Mitsubishi Bank, 88; repayments on Japanese debt handled, 23; represented on British Bankers Association, 94
Tokyo Capital Markets Bank of, 99
Tokyo City of, 18, 59, 91; visit of Lord Mayor 1994, 87
Tokyo Economist The, 3
Tokyo Electric Light, 147
Tokyo Fire Insurance Company, 104
Tokyo Securities, 96
Tokyo Stock Exchange (TSE), 39, 45, 98, 144; visit by Lord Mayor 1994, 86
Tonomura Mr Hitoshi, 142
Toshiba, 60
Touche Ross & Co, 111
Townsend Mr Sidney, 105
Toyo Rayon, 26
Toyo Trust International, 102
Toyota, 52
Trafalgar, 13
Treloar Sir William. *See* Lord Mayor of London
Tsingtao, 13
Tsushima Battle of 1905, 13

U
Underwriting, 135
Union Insurance, 103
United Nations, 112
United States of America: and Exchange Equalisation Tax 15, 25; relationship with Japan

Index

after WWI, 15; Treaty with
 Japan 1853, 1
University of Tokyo, 128
Uno Mr S, 95

V
Vemura Mr, 3
Vickers & Co, 12, 15
Vickers da Costa, 26, 37, 141
Vickers Mr Ralph, 27

W
Wako Securities, 37, 96
Wales, 52
Wales HRH The Prince of, 52
Warburg SG & Co, 62; admitted
 Tokyo Stock Exchange, 47; and
 Euroyen bond issue, 40; Japanese
 friendships, 37; lead-manages first
 Euroyen bond issue 1977, 40
Warner Sir Fred, 14, 18
Washington Conference 1921, 16
Washington Disarmament
 Treaty, 20
Westminster Bank (later National
 Westminster Bank), 18
Willis Faber & Co, 104, 107, 108
Wood Street, 65, 69

Y
Yamaguchi Mr Tsuguji, 113
Yamaichi International (Europe)
 Ltd, 95, 96, 102
Yamaichi Securities: leadership
 in Eurobond issues 1989, 51;
 membership London Stock
 Exchange 1986, 96; opens first
 office in Philpot Lane, 36
Yamazaki Mr, 157
Yanagi Mr Masuo, 149
Yasuda Bank (later Fuji Bank): opens
 City office, 19
Yasuda Fire & Marine Insurance,
 110
Yasuda Life, 62, 63, 67

Yasuda Mr Zenjiro, 128
Yasuda Trust Europe, 102
Yokohama, 103, 106; first railway, 4
Yokohama Bank of, 73, 99, 162;
 brief history, 160
Yokohama Specie Bank: early
 history, 155; now Bank
 of Tokyo, 21; opens City
 office 1884, 6; role in Japan
 government Loans, 7, 18; sells
 US dollars to Mitsui Bank
 1931, 20
Yokohama, 2
Yorihito Admiral HIH Prince, 16
York Archbishop of: speech, 60
Yoshihito: Emperor of Japan signs
 declaration of War on Germany
 1914, 13
Yoshimoto Mr, 95
Young of Graffham Lord: speech, 59

Z
Zaibatsu, 20